Victoria and Albert Museum

Tibetan Art

John Lowry

London Her Majesty's Stationery Office

ISBN 0 11 290109 3

Front cover illustration: plate 26

Contents

Introduction

Probably no other country has had its culture so profoundly influenced by geography as Tibet. Its relief, having an average altitude of more than 5,000 metres, the high mountains which lie along most of its borders and the climate, which is largely the result of its geography, have had a crucial effect on Tibet's relationship with its neighbours. They discouraged foreign invasion (particularly from the south and south-west) and occupation and even made it possible to hinder the entry of individuals, though they did not prevent it altogether. At the same time, they presented few obstacles to travellers and immigrants who were acceptable to Tibet. In other words, Tibet's geography and climate helped in her defence and gave her a measure of natural control over the frontiers with her surrounding countries. These were the great civilizations of Central Asia, India and China, from whom Tibet, which at first had a less well-advanced social and cultural development, derived many elements of her own civilization.

The most important of these was Buddhism which came from India to Tibet about the seventh century A.D. By that time the original teaching of the Buddha Shakyamuni had undergone much modification in its homeland. Also, as it spread through Central Asia to China, it took on a certain amount of local colour, some of which was passed on to Tibet. At the beginning of its introduction into Tibet Buddhism came into conflict with the indigenous folk-religion. While it undoubtedly had to make concessions, the fact that Buddhism prevailed may have been due to widely held primitive beliefs, common to Tibet and India, which had been absorbed into Buddhism in India, finding their counterpart in Tibetan folk-cults more or less systematized under the name of Bon. In spite of this, the doctrines of Tibetan Buddhism are ultimately no different from the teaching of its founder (see pl. 2), but the centripetal pattern of its absorption, and its connection with Tantrism (see pl. 11), have given rise to a religion whose practices are not only highly characteristic but have also left their mark on Tibetan culture.

The relationship between religion and culture in Tibet is rather similar to that which existed between Christianity and the culture of medieval Europe. In each case religion inspired the art and architecture which were created for its glorification. As in Europe at that time, the art of Tibet is largely devoted to the service of religion. The great monasteries and wealthy laymen were probably two of the most frequent patrons who employed painters, sculptors and craftsmen in wood, metal and stone to make objects for ritual use and private devotion.

One of the effects which the combination of elements from neighbouring countries with indigenous cults has had in the field of visual art in Tibet is the creation of a vast pantheon comprising hieratically arranged deities representing almost every conceivable nuance of religious thought. These range from the idea of a supreme deity as the ultimate origin of all things (see pl. 1), which probably arose in late Buddhist thought in India, to countless defenders of the faith (Dharmapalas; see pls. 15 & 28) recruited from local Tibetan gods and Central Asian deities. Also from India probably came the cult of the group of Mahasiddhas (see pl. 10) while the series of sixteen, or eighteen, Arhats was possibly introduced from China (see pl. 24). In between are numerous other categories, or variations of the more common types of deity. Many of these were created out of the imagination of revered scholars who described them in commentaries which they wrote to elucidate other texts. Images corresponding to such deities are, therefore, usually incomprehensible divorced from the texts in which they appear.

The aim of the Tibetan artist, who sometimes may also have been an incarnate Lama, was not to create something which expressed his own ideas or personality but to preserve as much as possible the continuity of the tradition in which he had been trained. As a rule there was no desire to innovate or depart from the conventions which had been observed by previous generations; to do so would not only have been disrespectful to his religion but also might diminish the efficacy of the image he was making or painting. Occasionally, perhaps by the power of his personality and undoubted talent, an individual artist worked in a manner which was conservative, yet in a new kind of way (see pl. 23) and thus established a characteristic style which was imitated and later came to be recognized as a clearly defined school. The sMan-bris and Karma-sGar-bris schools of painting are said to have been founded in this way. Craftsmen were trained as apprentices in workshops where they learned their trade by doing different jobs until these had been mastered. When this had been done, they worked mainly by commission, either copying well known models of the more familiar deities and scenes or, in the case of

the less familiar ones, getting help with their design from a learned monk, who was able to consult the appropriate text. Although the names of artists who painted the walls of some of the early monasteries are known, they seldom signed their smaller work such as t'angkas and bronzes. Thus Tibetan art is nearly always anonymous.

One other result of Tibet obtaining her culture from a variety of sources was the parallel acquisition of several art styles and motifs. Although these influences were reflected in her art at a very early stage and continued throughout most of her history, the impression they made was usually uneven and sporadic. Undoubtedly the strongest earliest influence came from India. The first monastery which was built in Tibet, Samye (see pl. 26), about A.D. 790, was modelled on that at Odantapuri, which was situated not far from present-day Patna in Bihar. Tibet sent scholars to India to collect religious books, and Tibetan monasteries paid large sums to Indian teachers to visit Tibet. There can be little doubt that these exchanges were responsible for introducing and spreading Indian canons of taste. This is shown quite clearly by the earliest Tibetan bronzes, which are closely related in style to those of the late Pala period in India (see pl. 2). The cultural influences of Central Asia are less clear. This is partly because Central Asian art itself is eclectic, and partly because much of the material culture of Central Asia has been destroyed. But it is recorded that monks from Central Asia visited Tibet and it is likely that a similar pattern of cultural exchange grew up between Central Asia and Tibet to that which took place between India and Tibet. Probably the most marked influence from Central Asia was the technique of wall-painting which it had inherited from India and which was later widely used to decorate Tibetan temples. But, after India, it was from China that Tibet received its most positive cultural stimulus, and one which has continued for longer than any other. Its effects were possibly contributed through more secular channels than those received from India and Central Asia, although religious influences were not entirely missing. China's great contribution was in the field of art motifs which penetrated Tibetan art at least as early as the eighth century and some of which, such as the cloud-, rock- and water-motifs have remained until today. From the time Buddhism was first adopted Tibetan art was, therefore, eclectic; and foreign styles existed alongside that which could be regarded as a distinct but evolving national style until about the sixteenth century. After the disappearance of Buddhism in India, Kashmir and Central Asia, the two most important sources of stylistic influence were those of Nepal and the art of North China as it

was related to the Buddhism of Tibet practised by the Mongols. Thus, in addition to the Tibetan national style, there existed, from about the fourteenth to the sixteenth century, a Sino-Tibetan and Tibeto-Nepalese style which it is often difficult to assign positively to either of the two countries concerned. From the seventeenth century these foreign influences were gradually absorbed into the national style. Within the national style Tibetans themselves distinguish several schools of painting and sculpture whose origins are attributed to the influence of historical personages such as famous religious men. As well as different styles resulting from foreign influence, the conservatism of tradition and, probably, the tendency for archaic forms to reappear, make it difficult to trace the path of Tibetan art history with any clarity. Another factor which may have restricted the development of clearly defined styles was local geography. In the secluded valley communities it is conceivable that workshops operated in semi-isolation unaffected by outside influences. Conversely, a new influx of ideas may have been brought in by one of the many travelling craftsmen, perhaps from Nepal or one of the other border countries, who might have decided to stay and settle down. But, for whatever reasons, the development of Tibetan art is not usually dynamic but tends to remain semi-static over many decades, such changes as there are taking place only slowly. The precise assignment, therefore, of date and provenance to items of Tibetan art is unusually hazardous. For this reason those given in this booklet are, in most cases, provisional. It could be said that, as the identification of subject matter and the assigning of date and provenance in Tibetan art are sometimes less certain than in some other cultures, its merit must rest almost entirely upon its aesthetic appeal. While this must remain a question of personal taste there can be little doubt that, in spite of its conservatism, it is its vitality which is the main characteristic of the national style of Tibetan art and which not only makes it truly Tibetan but also ensures that it can safely be judged against the best of Asian art.

The Museum began collecting Tibetan art more than 100 years ago with, amongst other things, the acquisition of part of the collection made by the brothers Schlagintweit during their travels in Tibet in the sixties of the last century. This booklet is, however, the Museum's first publication dealing with this subject. It is hoped that it will fill a gap in its published material covering the art styles and periods represented by its collections. The illustrations have been chosen both to show some of the finer examples of Tibetan art and also to give some idea of the scope of the collection. In this context the word 'Tibetan' has been interpreted broadly to include examples from

surrounding countries whose art has been affected to a certain extent by that of Tibet.

In most cases the names of deities, etc., are given in Sanskrit. This apparent anomaly is the result of two considerations. First, except to Tibetan specialists, they are much better known by their Sanskrit than by their Tibetan names; second, because of the wide divergence between written and spoken Tibetan only readers with some knowledge of the spoken language would be able to pronounce the names printed as spelt in Tibetan. It is true that the sounds of the Tibetan language can be fairly simply expressed by a system of Roman letters; but even this has to be learnt. However, if this is done without giving also the precise transliteration, it is difficult for the reader who wishes to seek further information to relate the spoken form with references in which the Tibetan written names are given. On balance, therefore, it has been thought better, in a booklet intended for the general reader, to omit the Tibetan names in most cases. Those who are sufficiently interested in the subject can easily find out the Tibetan names in some of the excellent reference books which are available. In the index the Tibetan words are listed under their initial letter.

The captions are divided into two parts. The first gives a short description, then the dimensions (height before width), followed by the Museum inventory number. The second section gives further information about the object shown in the illustration, including, in some cases, background material relating to its cultural context.

Short Bibliography

Pal, P. *The Art of Tibet* (Asia Society Exhibition Catalogue). New York, 1969.

Snellgrove, D. *Buddhist Himàlaya*. Oxford, 1957.

Snellgrove, D., and Richardson, H. *A Cultural History of Tibet*. London, 1968.

Stein, R. A. *Tibetan Civilisation*. London, 1972.

Tucci, G. *Tibetan Painted Scrolls*. Rome, 1949.

Tucci, G. *Tibet: Land of Snows*. London, 1967.

Plates

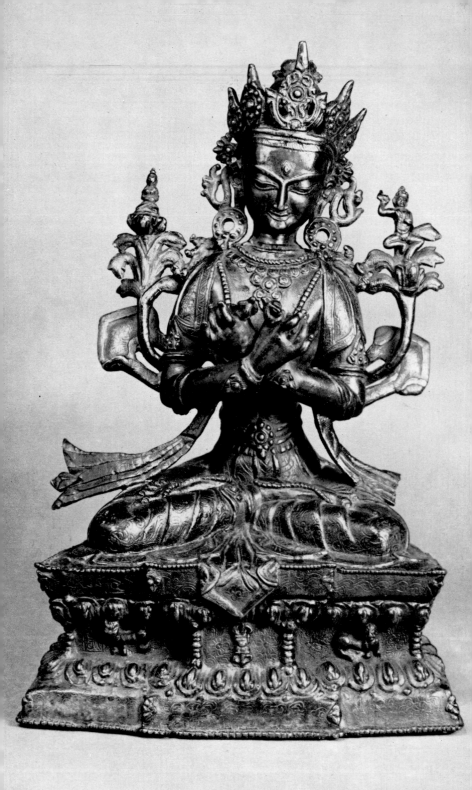

I Vajradhara. Bronze, engraved and inlaid with copper and silver. Possibly 15th century. H. 22.7 cm. (8$\frac{15}{16}$ in.). I.M.63–1936

In the developed form of Buddhism which Tibet inherited from India it is believed that, above all Buddhas and acting as a primal source from which all else flows, there lies a supreme deity who, unlike some other forms of Buddha such as Shakyamuni, will never come down on to earth amongst men. As is so often the case, his iconography is not precisely clear cut, and at least three separate forms are recognized (another is shown on pl. 29). The acceptance of each of these as supreme Buddha (Adi-Buddha) depends to a large extent on the teaching of individual sects. Vajradhara is regarded as supreme by the Gelukpa (Yellow Hat) sect, which was founded as a result of the teaching of Tsongkapa in the early fifteenth century, and to which all the Dalai Lamas have belonged. The image shown here is unconventional in having figures resting on lotus flowers at each shoulder. The bell (*ghanta*) symbolizes wisdom (*prajna*) and the thunderbolt (*vajra*) symbolizes method; they are held in *vajrahumkara mudra* the ritual hand-pose indicating the supreme (Adi-) Buddha. The concept of the relationship between wisdom and method is of fundamental significance in Tibetan Buddhism.

In Tibet images are not regarded merely as symbols of the deities they represent but as the locus of the deity itself. They are the point of contact between the worshipper and the worshipped and are thus the means by which prayers can be conveyed directly to the deity to whom they are addressed. Images are consecrated by placing prayers or *mantras*, relics, etc., inside the base and sealing it with a copper plate engraved with a double thunderbolt. Most images reaching the West have had these objects removed.

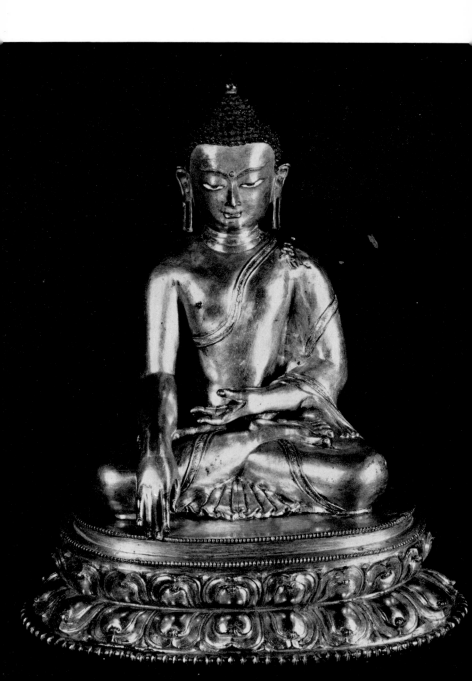

2 The Buddha Shakyamuni. Embossed copper, gilt and partly painted. Probably 14th century. 41.9 cm. (16½ in.), 34.3 cm. (13½ in.). I.M.121–1910

Although Tibetan Buddhism comprises teaching and practices which evolved long after the time of the Buddha, its fundamental thought, the veneration of the 'Three Jewels' (*Triratna*), The Buddha, The Teaching and The Monkhood, belongs to ancient tradition (see also pl. 27). In relation to other deities in the pantheon, figures of Buddha Shakyamuni form only a small proportion and, in numbers, are possibly less than those of Amitabha and Padmasambhava.

The figure shown in this illustration represents a Tibetan interpretation of the late Pala art of north-east India as it was received through Nepal. Indian influence can be seen in the treatment of the figure and the robes.

The origin of the lotus symbol which forms the throne on which he sits is rooted deeply in Indian mythology belonging to well before the start of the Buddhist period. Its association with water, and therefore with ideas relating to the origin of life (see pl. 40) is evident. It was similarly regarded by the ancient Egyptians, who may have transmitted the conception to India.

This image's facial expression of tranquillity combined with immense spiritual power recalls the similar effect created by the eyes of the Adi-Buddha on the Great Stupa at Bodnath, Nepal.

Amongst other items found in the base of this figure were a series of drawings of deities, one of which is reproduced in plate 31.

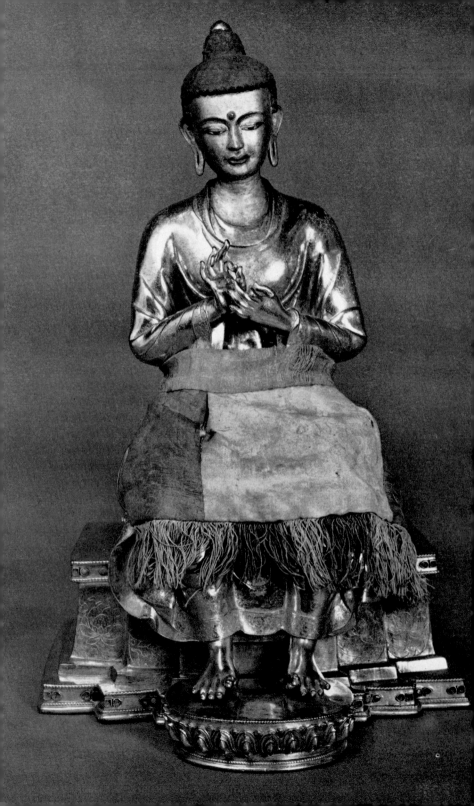

3 Maitreya. Gilt bronze engraved and painted and set with semi-precious stones, and with an apron of silk damask. Probably 15th century. 50.1 cm. (19¾in.), 31.7 cm. (12½in.). I.M.6–1913

Maitreya, following in due course the Buddha Shakyamuni, waits in the Tushita heaven until it is time for him to descend on to earth to become the next Buddha. He is, therefore, still a Bodhisattva; but in Buddhist art he is shown both in the princely garments of a Bodhisattva (see pl. 21) and, as here, dressed in the simple monk's robes of a Buddha. Unlike other Buddha figures (such as that shown in pl. 2) he is shown sitting in the 'European' posture. This is intended to represent the moment in time when Maitreya, who has been sitting in the conventional *dhyanasana* posture of a Buddha with his legs crossed, uncrosses them in order to come down from heaven. His hands are in the preaching attitude (*dharmachakra mudra*).

The red and yellow damask apron worn by this figure is probably part of a more complete set of robes. This follows the common Tibetan practice of dressing up the more important temple images in clothes and, sometimes, jewellery. This tradition may go back to the Pala period in India, where the principal image of the Buddha Shakyamuni at Bodhgaya was dressed in royal robes at festival times. (This, in turn, may have given rise to the anomaly of the image of Shakyamuni permanently portrayed wearing the costume of royalty.)

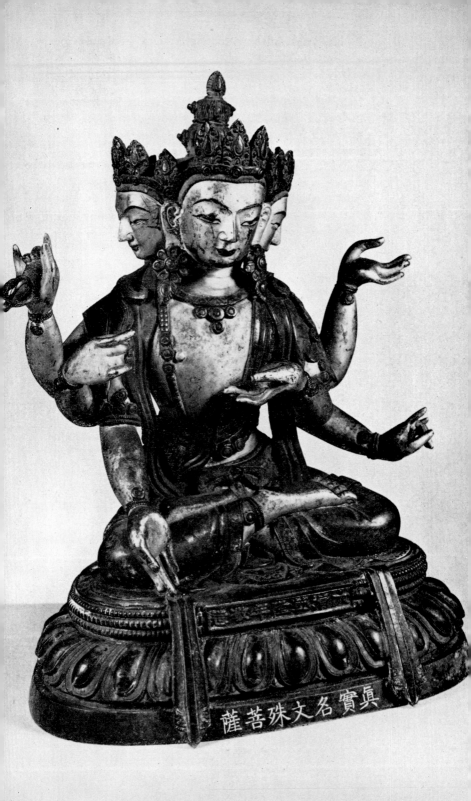

真實名文殊菩薩

4 Namasangiti-Manjushri. Bronze with traces of painting and gilding. Late 18th century. H. 17.2 cm. (6¾ in.). I.M.29–1929

The inscription in relief at the top of the throne gives the reign-mark of the Chinese emperor Ch'ien Lung (A.D. 1736–95); the engraved inscription on the bottom of the throne gives the name of the deity (Chen-shih-ming Wen-shu p'u-sa). This is one of the more unusual forms of Manjushri. It is almost identical with a similar figure belonging to a large pantheon which may have been given by Ch'ien Lung to his mother on the anniver-saries of her sixtieth, seventieth and eightieth birthdays (A.D. 1751, 1761 and 1771), possibly the last. From this image it can be seen that the one in the illustration opposite held a sword in the upper right hand and an arrow in the middle one; also a lotus in the upper left hand, a book in the middle one and a bow in the lower. According to Indian descriptions of this deity he should have a figure of Akshobhya in his crown, which has been omitted.

This figure illustrates the continuity of tradition which linked both the art of Tibet and that of the Tibetan church in northern China (mainly Peking) from the time when each country was under the domination of the Mongols. The style of this bronze, while remaining recognizably Chinese, at the same time also belongs firmly to Tibetan traditions of bronze sculpture.

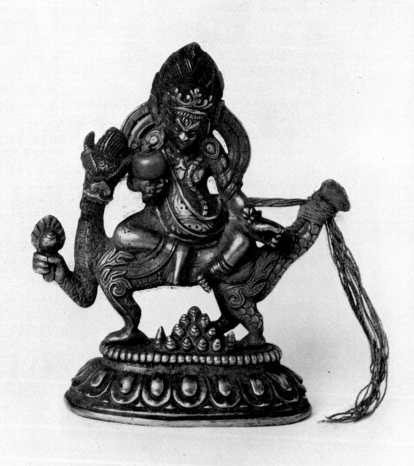

5 White Jambhala. Bronze, gilt and engraved, and with an amber bead and silk (?) thread. Probably 17th or 18th century. H. 8.8 cm. ($3\frac{1}{2}$ in.). I.M.43–1929

This deity has a long and complex history in the development of the Buddhist pantheon. Starting, probably, with pre-Hindu origins, in response to the widespread human desire for the accumulation of material wealth, he entered the *Vedas*, however, as the king of evil spirits (Kuvera) and only later became associated with fertility and wealth. In early Buddhism he retained this association and was probably related with Panchika. Later, with the absorption of many Central Asian deities into the Buddhist pantheon, he became linked with one of the gods guarding the four directions (see pl. 9). But, through his relationship with Panchika, he retains his role as the god of wealth quite separately from his close relative, who is the guardian of the north. His fierce expression is all that remains of his early association with a guardian deity, while his dragon mount betrays his exposure to non-Tibetan mythologies to the north and north-east. Panchika's consort, goddess of fertility and riches, was Hariti, who probably became Vasudhara (see pl. 8), and these two are often invoked together as a pair. The iconography of the image shown in the illustration is not entirely unambiguous. The original attributes in the hands are missing; the left hand probably held a jewelled club and the bead (probably from a rosary) may have been placed in the right hand in substitution for a trident.

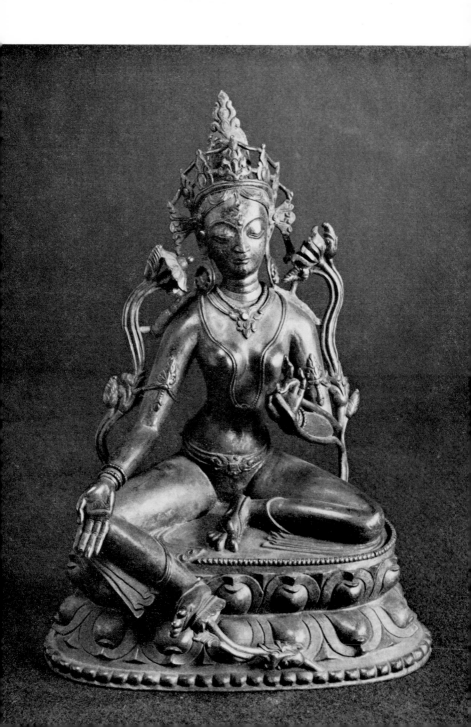

6 Green Tara. Bronze. Possibly 17th century. 32.7 cm. (12¼ in.), 22.8 cm. (9 in.). I.M.37–1929

While the cult of Tara (the 'Saviouress') seems to have sprung into prominence in Tibet about the eleventh century A.D., this was probably the culmination of a movement which began some time earlier, perhaps as yet another manifestation of the primitive worship of the mother-goddess. The Green Tara is one of a group of twenty-one Taras of whom she and the White Tara seem to enjoy a popularity almost equal to that of Avalokiteshvara. A well-known legend connects both of them with the wives of the Tibetan king Srong-btsan-sgam-po (about A.D. 615–50). It regards the king as an incarnation of Avalokiteshvara, his Nepalese queen as that of the Green Tara and his Chinese queen as that of the White Tara.

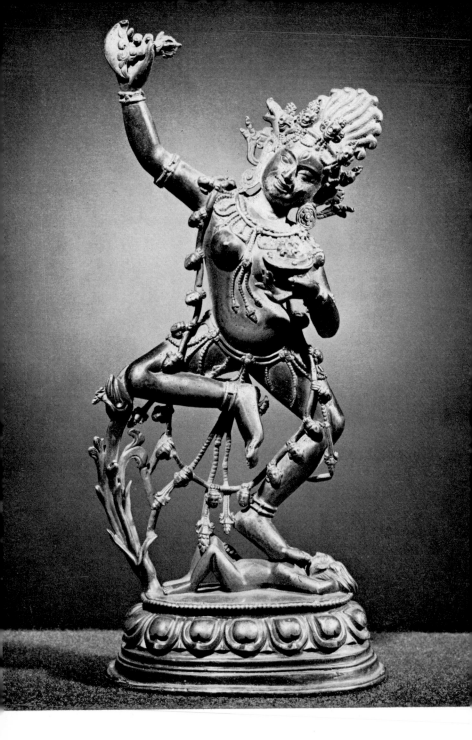

7 Vajravarahi. Bronze, formerly partly painted and gilt. Probably 16th century. H. 23 cm. (9 in.). I.M.197–1937

From the earliest period in Hindu history some female deities represented natural phenomena (such as Pritvi, the earth or Mother Goddess, and Ushas the dawn). Later, some Hindu and Buddhist gods acquired wives who became deities in their own right, of whom a small number gradually achieved a certain measure of independence. Vajravarahi is one of these. Although she is the *prajna* (see pl. 11) of Shamvara, she has her own *mandala* (see pl. 30) and her own retinue of lesser goddesses. She also belongs to the group of feminine deities known as Dakinis who, in tantric rites, were invoked in order to acquire supernatural powers. The tendency for the identity of some Tibetan deities to become merged with others is illustrated by the pig's head which protrudes from this deity's right ear, associating her with another female deity known as Marichi, in whose mythology a pig also appears.

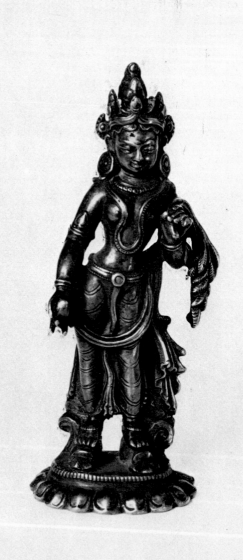

8 Jamari-Krama Vasudhara. Bronze. Possibly 12th century.
H.10.8 cm. (4¼ in.). I.M.39–1929

Vasudhara became a popular deity in Nepal, where she is usually
shown seated and with six arms; four-armed images are known
but those with two arms, such as this one, are uncommon. In
most cases, however, the image can be identified by the ear of
corn (?) which is held in one of her hands. This, perhaps, confirms
her northern origin and may also be intended to symbolize
fecundity. As Vasudhara is usually regarded as a goddess of
wealth and fertility it may represent the latter aspect, while the
vase, which is another of Vasudhara's attributes (here she
stands with one under each foot), symbolizes the former. It is
possible that this deity has been taken over from the Hindu
pantheon, where she was known as Lakshmi (or Hariti); in the
latter form she is regarded as the consort of Jambhala, the god
of wealth (see pl. 5). The image here also holds a jewel in her
right hand emphasizing her relationship with wealth.

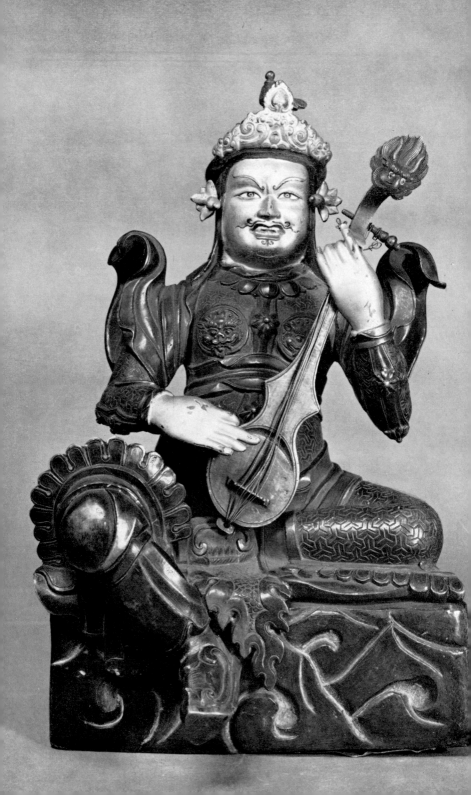

9 Dhritarashtra. Bronze partly painted and gilt. Probably 18th century. H. 30.5 cm. (12 in.). I.S.83–1948

This deity is one of the Guardians of the Four Directions (*Lokapalas*) and is responsible for protecting the Eastern quarter. The Guardians are also known as the Four Great Kings; they probably originated in the pre-Hindu mythology of India and were taken into Buddhism at a very early date. They are referred to in early Buddhist texts describing the life of the Buddha, where they are said to be present at each important event in his career. In Hindu mythology the *Lokapalas* guard the four slopes of Mount Sumeru, the mountain which forms the centre of the universe, while in Buddhism they have become employed in guarding the Sukhavati heaven.

Dhritarashtra wears the crown of a king; also, as a warrior, he wears armour which seems to be based on a characteristically Chinese pattern.

His identifying symbol is a musical instrument having the Tibetan name *sgra-snyan* (see pl. 46). In Tibetan painting he frequently appears in series representing *Arhats* (see pl. 24) often accompanying Hva-shang. He can also be seen with his three other companions at the bottom of the Assembly Tree of the Gods (see pl. 28).

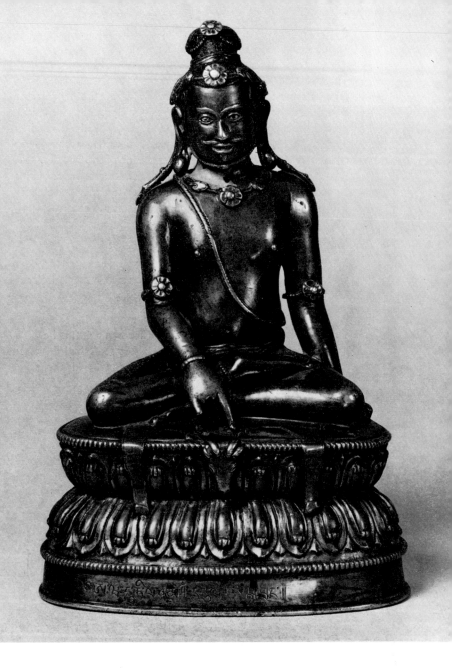

10 The Mahasiddha Avadudhipa. Bronze, with the eyes inlaid with silver and with traces of painting on the face. 14th or 15th century. H.18.4 cm. ($7\frac{3}{16}$ in.). I.S.12–1971

A *mahasiddha* is a person (male or female) who has become highly skilled in the practice of Tantra; he has achieved success (*siddhi*) in the acquisition of supernatural powers, such as making himself invisible or flying through the air, which give him control over the forces which direct this world and the next. He uses these powers not only for his own benefit but also for the salvation of all mankind, for whom he continually works. In Tibetan art there is a group of eighty-four *mahasiddhas* which is related to a similar group found in late Buddhist and Hindu Tantrism in India.

As well as the name given above (which is that mentioned in an inscription round the base), this figure is also known as Dhi li, De li pa, Te li, Tillipa and Tsampakari. The name also appears as Advayavajra, or Maitripa, and these were given to an Indian teacher who lived at both Nalanda and Vikramashila and who had among his pupils Atisha and Marpa; it is possible, therefore, that this image is intended to represent him.

In Tibetan art representations of *mahasiddhas* show a great deal of variation particularly between the paintings and bronzes. In general, however, they are shown wearing a loin-cloth and a head-dress and jewellery made of flowers; they often have their hair drawn up into a chignon and sit on an animal skin.

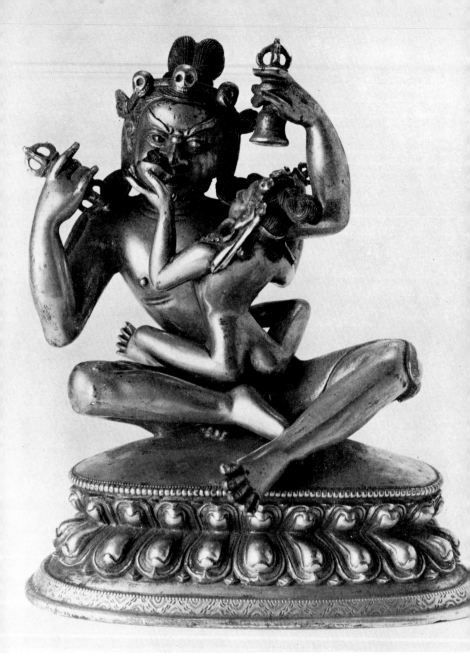

11 A Mahasiddha (probably Ghantapada) and his
prajna. Gilt bronze. Possibly 16th or 17th century. H. 22.7 cm. (8¹⁵⁄₁₆ in.). I.M.61–1929

If the identification of this figure is correct, he belongs to the same group as that mentioned in the caption to pl. 10.

The representation of two figures clasped in a sexual embrace is linked with both Buddhist and Hindu Tantrism. In Hindu tantric teaching the female is regarded as the active element of the partnership and she is known as *shakti*; in Buddhist Tantrism, on the other hand, she is regarded as having precisely the opposite function, that of the passive partner, and is called *prajna*. The symbolism of the pair in this posture covers a wide spectrum of thought from the concept of the union of the personal soul with the cosmic soul to the literal interpretation in the form of ritual performance of the sex act.

Tantrism's preoccupation with magic and elaborate ritual appealed strongly to Tibet at a very early stage in its absorption of Buddhism and has deeply penetrated its religious life. Much of the terrifying aspect of many of the deities and the emphasis placed on skulls, human skins and viscerae in Tibetan art is the result of tantric ideas.

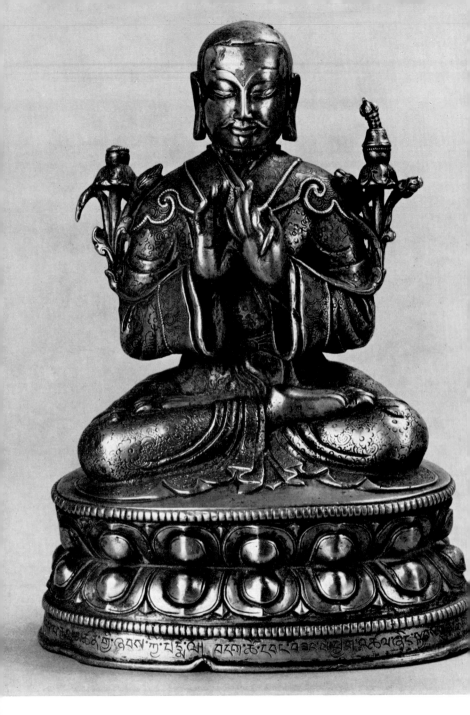

12 rJe-btsun Grags-pa rGyal-mtshan. Gilt bronze with
inlaid copper lips, and inlaid silver eyes, borders to the collar
and edges of the robe. Probably 13th century. H.18.5 cm. ($7\frac{1}{4}$ in.).
I.S.13–1971

The name of this figure is given in a dedicatory inscription run-
ning round the base. It is not possible to identify him further
with any certainty but there is a likelihood that he is the Sakya
Lama who lived from A.D. 1147 to 1216. If this be the case it is
probable that this image of him was made before the end of the
thirteenth century.

This is an example of the nearest thing to Tibetan portrait
sculpture, which forms a clearly defined *genre* within the field of
Tibetan sculpture. The obvious, and often successful, attempts
at creating a likeness show that, in spite of the conservatism of
his approach induced by his training, the Tibetan craftsman
never completely lost his powers of observation. Moreover, the
high degree of characterization which is achieved in some of
these bronzes suggests that, if they were not made during the
lifetime of the subject, they were probably made within the
memory of someone who knew him at first hand.

The technique of inlaying bronze images with silver and copper
was inherited by Tibet from India, Kashmir and Nepal, where it
was used to decorate images at least as early as the seventh
century A.D.

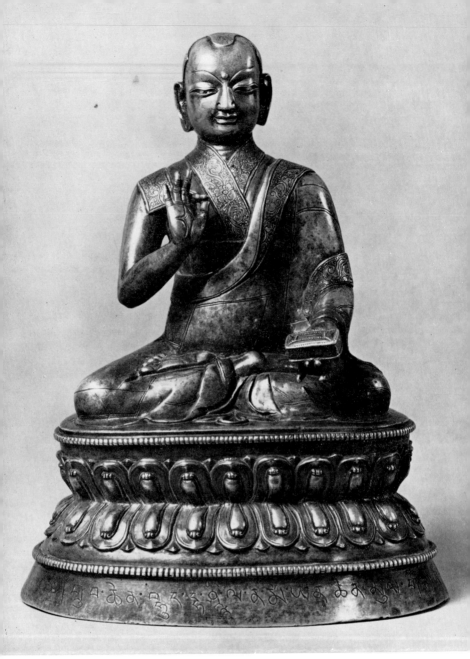

13 Buddhashri. Bronze with inlaid copper lips and silver and copper inlaid eyes. Probably 13th century. H.19.9 cm. (7¾ in.). I.S.10–1971

The name of this figure is given in a dedicatory inscription round the base. As with the image shown in pl. 12 it is not possible to identify this figure more precisely. It is probable, however, that he is the teacher who lived at the end of the twelfth and the beginning of the thirteenth century A.D., and that this portrait was made within a few decades of his death. That positive attempts were made by Tibetan craftsmen to achieve a true likeness of their subject is shown in this figure by the fact that the pupil of the left eye has been omitted, thus suggesting that Buddhashri was blind in this eye or, at least, that he had a wall-eye.

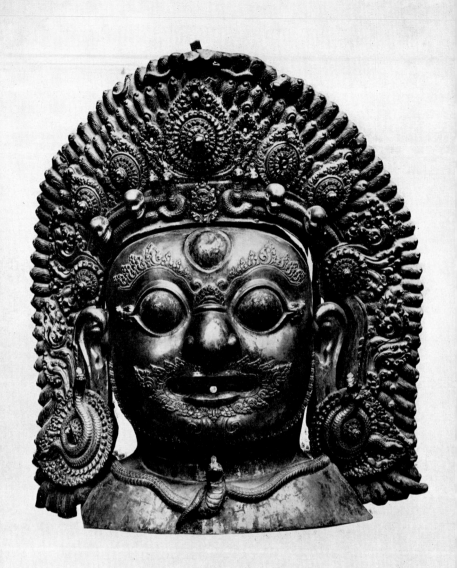

14 Head of Bhairava. Embossed copper, painted and gilt, and set with imitation gems. Probably 17th century. 69.2 cm. (27 in.), 64 cm. (25 in.). I.M.172–1913

Bhairava is a deity which is probably more popular in Nepal than in Tibet. Both countries have had close cultural ties from the earliest historical times largely as a result of Nepal lying on one of the main trade routes between Tibet and India. Newari craftsmen were frequently employed in Tibet, where, as in the case of Ngor monastery (see pl. 30), groups of them were sometimes engaged to execute wall-paintings and other interior decorations in chapels and monasteries. Conversely, it is probable that Tibetan craftsmen worked in Nepal. The resulting cross-fertilization produced schools of painting, sculpture and decoration in each country which are sometimes difficult to separate.

The head shown in this illustration shows characteristics from both schools. The treatment of the hair and face, and the form of the crown, belong to Tibet and Nepal. But the decoration of the crown and the iconography suggest that there is little doubt that it originated in Nepal. It may, possibly, have come from a large image; but it is more likely that it was used in a ritual associated with the cult of Bhairava in Nepal during which devotees take liquid through the hole in its mouth attached to a pipe, down which the liquid is poured from behind.

Embossing several sheets of copper, which are later joined together, is more often used as a technique for making larger images than casting, since it is more economical and makes them easier to handle.

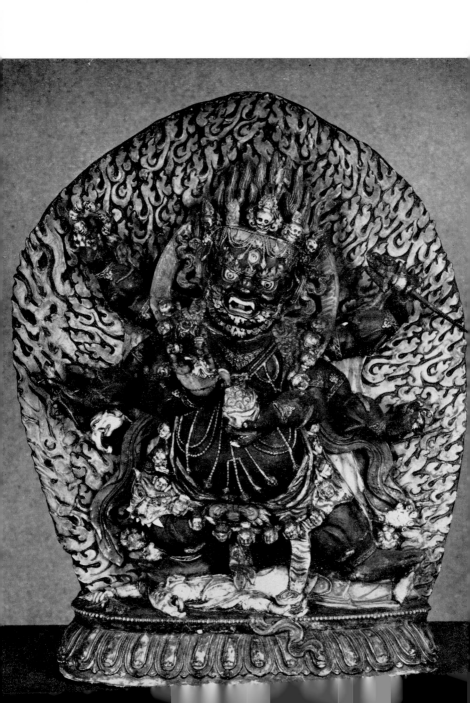

15 Mahakala. Modelled in a composition said to be clay, flour-paste and human bone ash, painted in tempera with some gilt and varnishing. 16th or 17th century. 37.7 cm. (15⅛ in.), 31 cm. (12¼ in.). I.S.178–1964

This deity has the rank of *Dharmapala* (defender of the faith) and his whole appearance is intended to overcome the enemies of Buddhism. The objects which he holds in his hands are also symbols of his power to defeat hostile demons, a snare (originally held in his lower left hand, now missing) to capture them, a chopper to cut off their life roots, and a skull-cup to hold their blood, etc. Mahakala is one of the *Dharmapalas* given special responsibility to defend the doctrine by the Gelukpa, or Yellow Hat sect.

Due to the fragility of clay figures they are seldom found outside Tibet, where the technique is widely used for sculpture inside temples.

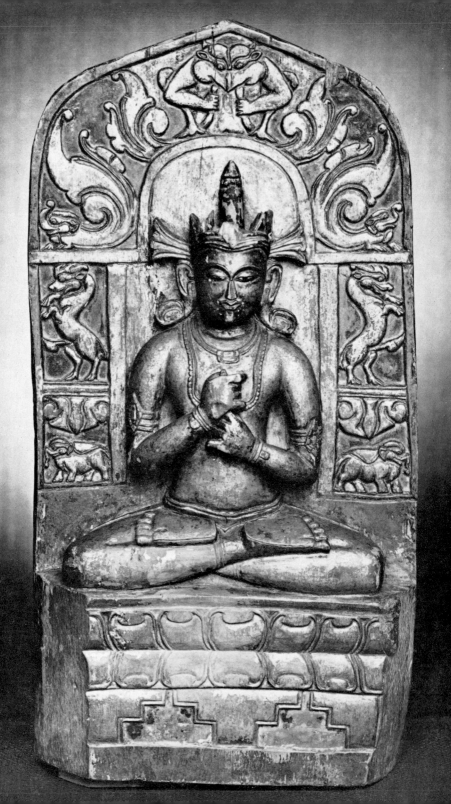

16 Vairochana. Wood, carved and painted and partly gilt. Possibly 13th or 14th century. 37.5 cm. ($14\frac{3}{4}$ in.), 19 cm. ($7\frac{1}{2}$ in.). I.M.20–1910

The stylized treatment of the animals decorating the back of the throne is not unlike that found on bronze plaques originating in ancient eastern Central Asia. While the length of time which separates the culture which produced them and this sculpture precludes a direct connection, the echoes of the earlier style may be sufficient evidence for attributing the provenance of this example to Tibet itself rather than to the Himalayas.

The use of these animals to decorate throne-backs in the way shown here is taken directly from Indian sculpture belonging to about the fifth century A.D. The lion and the *makara* (legendary reptile) in combination were probably used first, while the elephant and *kirttimukha* (legendary beast, half man, half animal) were added soon after. It is possible that they are intended to symbolize the status of the Buddha figure as a Universal Monarch. This type of throne also appears in Tibetan painting, where, sometimes, the structural element disappears or is replaced by flowers and foliage (see pl. 18). In contrast the back is sometimes formed entirely by the halo and mandorla and only the base remains to support the lotus seat (see pl. 19).

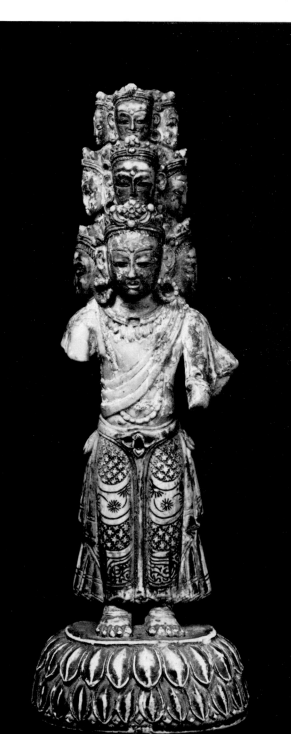

17 Avalokiteshvara. Agalmatolite ('pagodite') carved, painted, partly gilt and set with semi-precious stones and silver. Possibly 15th century. H.14.9 cm. (5$\frac{7}{8}$ in.). I.M.370–1914

As the arms have been broken it is not possible to identify precisely which form of Avalokiteshvara this image is; originally it had eleven heads and was probably intended to have four or six arms.

The quality of the workmanship is of the highest order and in its original state it must have been a most impressive object indeed. The material and technique, however, raise difficult problems of provenance. Stone sculpture, though not unknown in Tibet and the Himalayas, is not as widespread as bronze casting. The stone, similar to soapstone, of which this image is made is not found in India and its existence in Tibet has yet to be proved. It is, however, found in China, where it is frequently used for carving small images. In spite of having no Chinese stylistic characteristics it is possible that this piece may have been made in China.

The *mantra* to Avalokiteshvara (see pl. 49) in Lantsa letters is carved in relief on the back of the base.

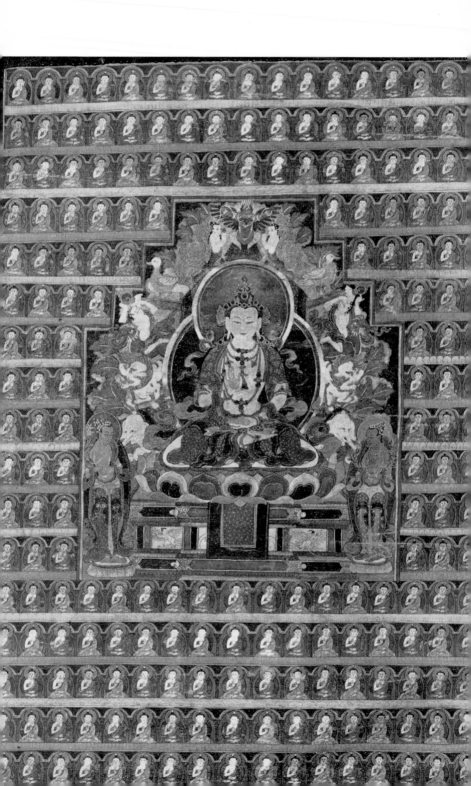

18 Amoghasiddhi, surrounded by 202 other figures of
Amoghasiddhi. *T'angka* (scroll-painting). Probably 18th century.
80 cm. (31½ in.), 56 cm. (22 in.). I.M.12–1932

T'angkas similar to this one showing a central figure (usually one
of the Dhyani-Buddhas) surrounded by rows of the same figure
are popular in Tibet. They form a stylistic group which seems to
be unrelated to other groups of *t'angkas* such as narrative,
genealogical or *mandala* paintings. The multiplication of figures
in this way is a parallel to the reduplication of prayers by various
means such as wind-operated prayer-wheels. Moreover, the
repetition of the same verbal formula (*mantra* or *dharani*) in
order to achieve a specific object is enjoined in several religious
texts. Thus the painting of many representations of the same
figure in wall paintings or *t'angkas* is probably regarded as being
more efficacious in invoking the aid of the deity than a single
figure.

The treatment of the area immediately surrounding the central
figure is characteristic of a school of Tibetan painting that has
not been positively identified. What is, in most cases, the
structural form of the back of a throne has here almost dis-
appeared and has been replaced by figures of animals, birds and
foliage.

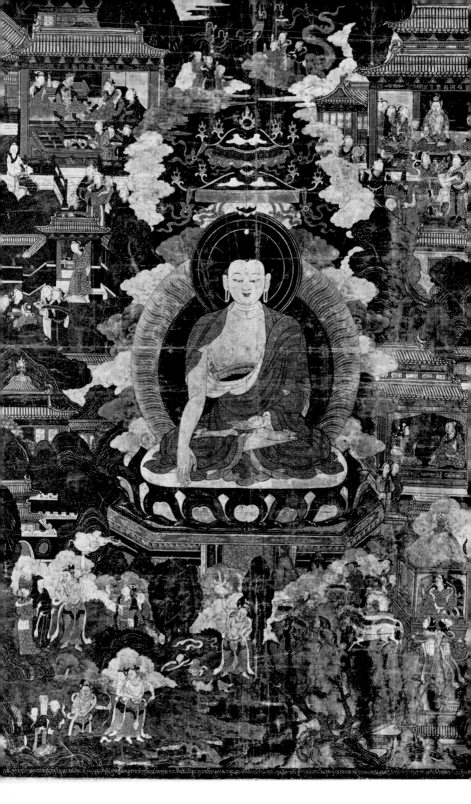

19 The Buddha Shakyamuni surrounded by scenes of incidents from his early life. *T'angka*. Dated A.D. 1686. 85 cm. (32 in.), 56 cm. (21 in.). 240–1890

This is one of a set of t'angkas, of which the Museum has three, probably showing each of the more important incidents of the Buddha's early life. It is almost certain that these scenes are based on one of the several Tibetan texts which describe the Buddha's life. This series should not be confused with others forming the basis of t'angkas (of which the Museum also has examples) which show incidents taken from the stories of his former lives (Jataka stories).

The three t'angkas which form the group to which this painting belongs are all dated by the same inscription, which, while it is in Tibetan script and in the Tibetan language, uses a Chinese regnal era. Very few Tibetan t'angkas are dated and those that are nearly always use Chinese or Nepalese systems of dating. The t'angka in the illustration, and its two companion paintings, are important for the study of the history of Tibetan painting since they provide positive evidence of the style of Tibetan painting at the end of the seventeenth century A.D. The inscription also records that these paintings were made at the dGa'-ldan Ch'os-'khor-gling monastery in Amdo province in north-east Tibet.

A comparison with the way the Buddha figure is treated here and in pl. 2 shows both the continuity of tradition and the subtle way that tradition has unmistakably become more Tibetanized.

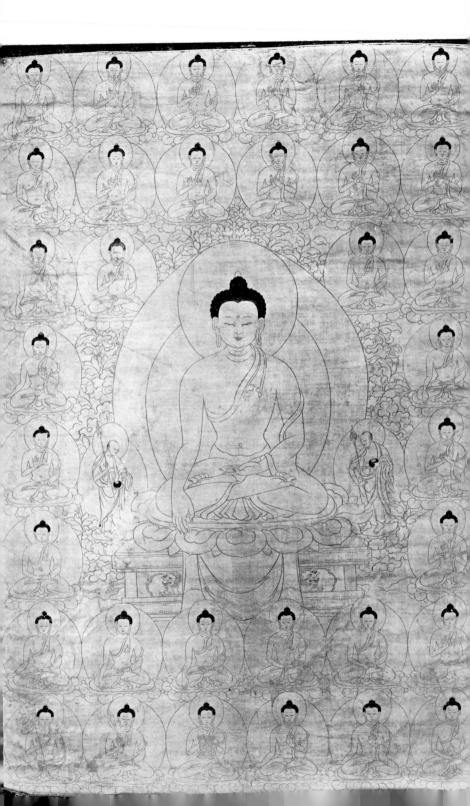

20 The Buddha Shakyamuni as the centre of the 35 Buddhas of confession. *T'angka*. Probably 18th century. 52 cm. (20½ in.), 45.5 cm. (18 in.). I.M.405–1914

In Tibetan iconography the Buddha Shakyamuni with 34 other Buddhas form a group of 35 which is a popular subject in painting and in literature, where each figure is described in detail. The group is the object of supplication for the removal of sins. On each side of the central figure are the Buddha's two chief disciples Shariputra and Maudgalyayana.

This *t'angka* belongs to a group, painted with a black outline on a plain gold background (or in gold on a plain red background), known as *gser t'ang* (golden *t'angkas*). Since the technique allows little or no correction of the drawing if an error is made, golden *t'angkas* are evidence of the high technical skill of Tibetan painters. While some *gser t'ang* have completely plain backgrounds, and are thus in two colours only (black on gold, or gold on red), others include small polychrome areas such as flowers or foliage; these form another sub-group of *gser t'ang* in mixed techniques. All three groups seem to be a late development in Tibetan painting which did not take place until about the eighteenth century. Moreover, its origins are unknown and *t'angkas* of this type do not appear to be confined to any particular area of Tibet.

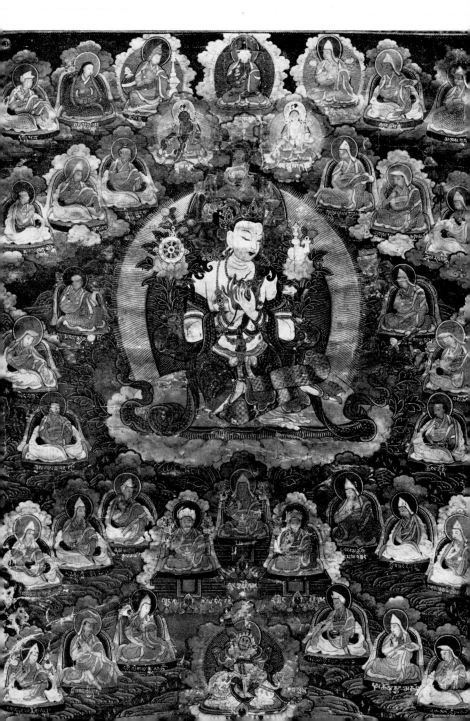

21 Maitreya surrounded by teachers and scholars of the Gelukpa (Yellow Hat) sect. *T'angka*. Late 18th or early 19th century. 57 cm. (22½ in.), 42 cm. (16½ in.). I.M.28–1938

This *t'angka* is one of a pair, both identical in style and treatment, the other showing Manjushri surrounded by a similar retinue. Each of them may be compared with the left-centre and right-centre branches of the genealogical tree (*Ts'ogs-shing*) shown in pl. 28. This one corresponds to the left-centre and can be fairly accurately dated by the fact that one of the figures shown is the VIIIth Dalai Lama, who died in A.D. 1804.

T'angkas showing the spiritual lineage descending from a deity to an historical personage or, alternatively, back from an historical personage to his spiritual origins form a distinct group in Tibetan painting. They are described in texts in which the traditions of these genealogies have been preserved. In some cases, as on this *t'angka*, the names are inscribed; the painting is thus made up of a series of portraits, the majority of which, however, are based more on conventional renderings of the person's appearance than on an actual likeness.

Maitreya is shown here as a Bodhisattva. He appears in pl. 3 as a Buddha.

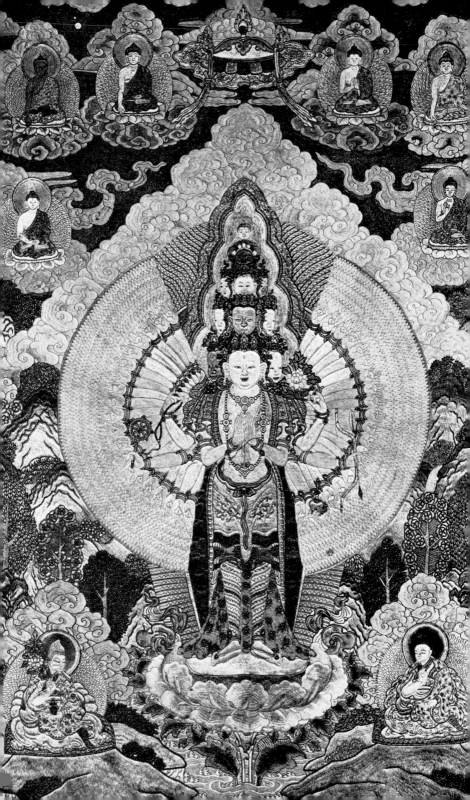

22 **Aryavalokiteshvara** surrounded by Dhyani Buddhas and Gelukpa scholars. Embroidery, in the form of a *t'angka*. Dated A.D. 1783. 126.4 cm. (49¾ in.), 73 cm. (28¾ in.). 1479–1902

Tibet has a long tradition of embroidery using the appliqué technique, both for secular use and for making religious pictures, some of which are of considerable size. Needle embroidery can be traced to an embroidered Buddhist picture which was probably made in China in the early part of the eighth century A.D. but was found on the borders of Central Asia. A similar technique was used for the picture shown in this plate; and as the reign-mark on the back refers to the regnal era of the emperor Ch'ien Lung, it is probable that it was also made in China. The design is based on painted *t'angkas* and corresponds precisely with the current style of painting of the same period.

An almost identical embroidery, dated A.D. 1778, is in the Metropolitan Museum of Art, New York.

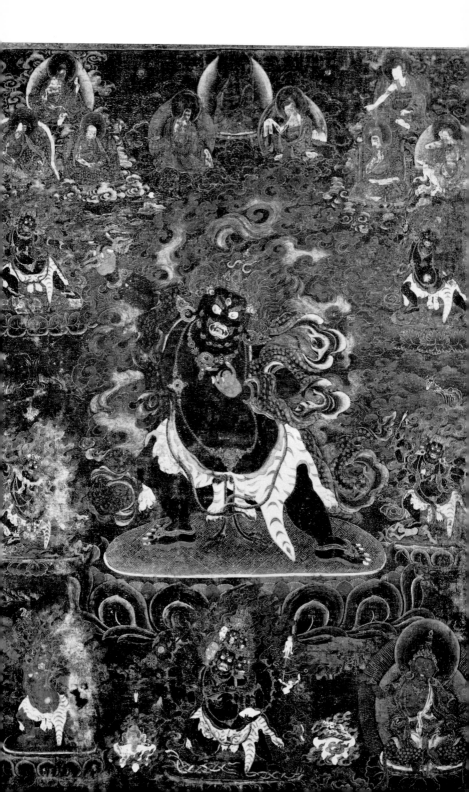

23 The Yidam (Tutelary Deity) Nilambaradhara Vajrapani. *T'angka*. Probably 17th or 18th century. 88 cm. (34⅜ in.), 62 cm. (24¾ in.). I.M.33–1937

This *t'angka* is painted in colours on a black ground and is therefore probably a *mGon-kang* painting. The *mGon-kang* is the inner chapel of a monastery (often underground), where the Yidam (i.e. the fierce aspect of the monastery's patron deity) is placed; it is accompanied by images of other guardian deities. Continuous prayers are said in the *mGon-kang* in order to ward off calamities which might be brought about by hostile forces. As all natural light is often completely excluded, the rituals take place in semi-darkness, to which the black background of *t'angkas* painted for use in the *mGon-kang* contribute their own sense of mystery and awe.

All except one of the deities shown in this painting are identified by inscriptions. The style of the execution (which is characteristic of other *t'angkas* both in the Museum's and other collections, and suggests a particular artist or school) is a superb example of the way in which a Tibetan painter, while working closely within a strong tradition, can nevertheless give an outlet to his artistic expression. The overall design, the spirited drawing and, above all, the sensitive use of colours are combined in this *t'angka* to create what must be a work of art judged by any standards.

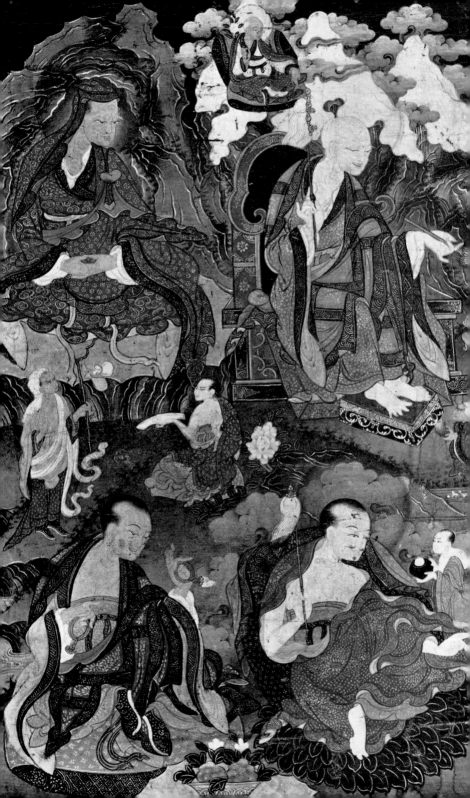

24 Four Arhats, seated in a landscape. *T'angka.* Probably 18th century. 62 cm. ($24\frac{5}{8}$ in.), 43 cm. ($16\frac{1}{2}$ in.). I.M.409–1914

At the top, left, is Ajita; he came from a wealthy family and is said to have been ordained by the Lord Buddha himself. At the top, right, is Angaja. He was also ordained by Buddha and is now said to be living on the summit of Mount Kailasa. At the bottom, right, is Vanavasin. He was described by the Buddha Shakaymuni as the Arhat who led the most spiritual life of meditation and solitude. At the bottom, left, is Kalika. He was the son of a wealthy Brahman; he preached the doctrines of Buddhism to children, who rewarded him with gifts of jewellery which he turned into earrings and gave back to them to show that they had heard and understood what he said.

An Arhat is one who, by meditation on the significance of the Noble Eightfold Path, has released himself from the fetters which bind him to wordly existence and will thus enter Nirvana after the death of his physical body. In Tibetan painting Arhats are represented in a group of sixteen, or the same group with two more added making a group of eighteen. These are sometimes all shown together on one *t'angka* or, possibly more often, in sets of three or five *t'angkas*, to which the painting shown in the illustration probably belongs. The cult of the Arhat, particularly in a group of sixteen, belongs originally to Indian tradition but seems to have become especially popular in China and Tibet.

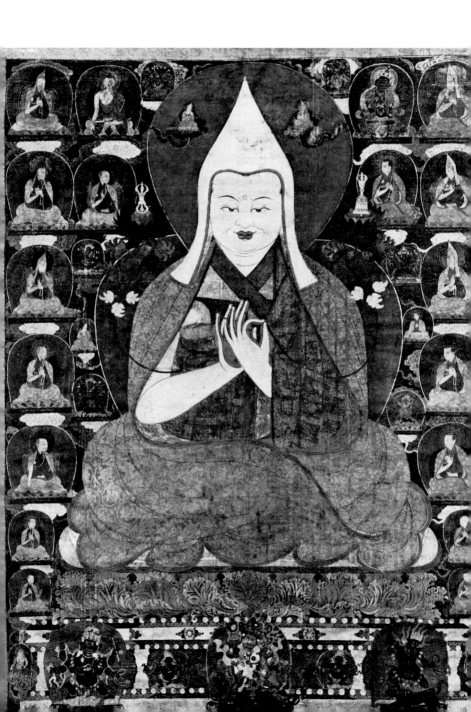

25 Figure of a Learned Monk (probably rJe-shes-rab-sen-ge) surrounded by his spiritual lineage. *T'angka*. Probably second half of the 15th century. 202.5 cm. (89 in.), 148.5 cm. (58⅞ in.). I.S.169–1964

This *t'angka*, in which the lineage of the central figure is traced back to its origins, is in contrast to that shown in pl. 21, which traces the lineage forward. Spiritual lineages such as these can be constructed because an aspiring scholar would seek out a teacher with a high reputation, who probably specialized in the exposition of a particular text or texts, and become his pupil. Later, when he achieved fame on his own account, he would in turn become a well-known teacher passing on his learning and that of his predecessors to his own pupils. Lists of the resulting lineages, often with details of the branches of religion specialized in, were recorded in texts.

As a continuation of his academic career, a monk may take up an appointment in his own monastery or elsewhere such as one of the important monasteries at Lhasa or one of the two colleges specializing in tantric studies in Lhasa, the rGyud-stog-pa and the rGyud-smad-pa (the Upper and Lower Tantric Colleges). The latter was founded by rJe-shes-rab-sen-ge in 1433. His identification as the central figure of the painting opposite rests on details of his iconography and the inscribed names of the surrounding figures. He was born at sNar-thang and became a pupil of Tsongkapa. Later he was one of the teachers of dGe-'dun-grub (1391–1475, retrospectively designated 1st Dalai Lama) with whom he founded Tashilhunpo monastery. He died in 1455.

It is unlikely, therefore, that this painting was made before about the middle of the 15th century and this attribution is supported by the treatment of the throne and textile pattern of the robes, and the shape of the mandorla and halo. As well as its somewhat unusual size, this *t'angka* is remarkable for the use of gilt decoration in low relief in some areas. It is likely that this effect was produced by the use of stamps applied to a thin coating of a putty-like substance, which was later gilded in the usual way.

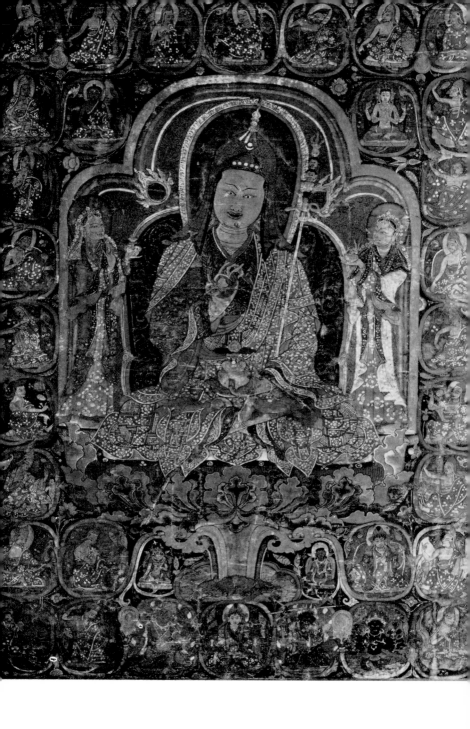

26 Padmasambhava, with his two wives and surrounded by his disciples. *T'angka*. Probably 14th century. 58 cm. (23 in.), 43.2 cm. (17 in.). I.S.20–1970

Padmasambhava was a famous *Siddha* (perfect one) who is also regarded by some sects in Tibet as equal in status to the Lord Buddha. In the second half of the eighth century A.D. he was invited to go to Tibet from his homeland, which was probably in what is now the Swat area of Pakistan, to teach and advise on the foundation of the first Buddhist monastery in Tibet (Samye). He created a great impression with his knowledge of Tantrism and tantric practices, then reaching their most developed form in India. After his death he was deified and became the patron deity of the Nyingmapa (Red Hat) sect. In Tibetan art he is usually shown, as he is here, with a skull-cup in his left hand and *vajra* (thunderbolt) in his right while he supports in the bend of his left elbow a flaming trident decorated with heads, a double thunderbolt and white ribbons (see pl. 45). He wears a characteristically shaped hat (usually shown with the lappets turned up) decorated with the sun and crescent moon symbols, three or five discs, and sometimes with a vulture's feather on the top. In paintings he is often shown surrounded by ten of his other manifestations, or as king of his own paradise situated on a copper-coloured mountain.

The 25 (sometimes 26) disciples which form the subsidiary figures of this painting are somewhat unusual; most of them were *siddhas* who were skilled in the arts of magic, some were Padmasambhava's assistants in the founding of Samye and one was King Thri-song Det-sen (A.D. 742–about 797).

The style of this *t'angka* is similar to that usually associated with western Tibet. A characteristic of this style is the foliage tendrils enclosing the figures. The use of these tendrils may have originated in Gandhara, whence it may have come from the art of the eastern Mediterranean (see pl. 48).

This *t'angka* is also illustrated on the front cover.

I

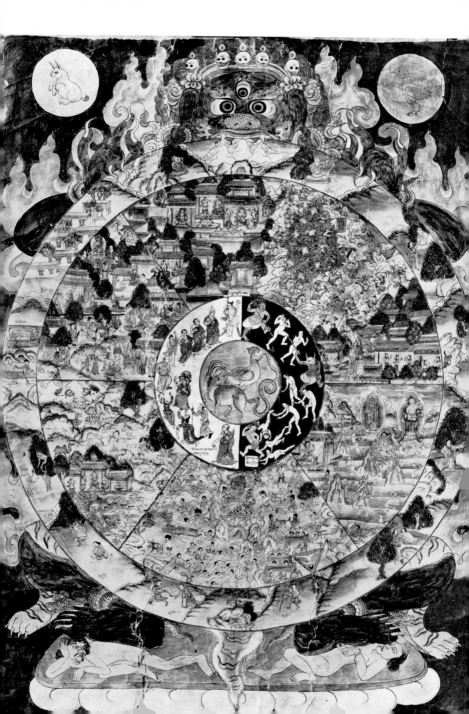

27 The Wheel of Life (Bhavachakra). *T'angka.* 18th or 19th century. 122 cm. (48 in.), 92.5 cm. (36½ in.). I.M.48–1912

The Wheel of Life probably has the oldest ancestry of any Tibetan form of scroll-painting, having originated from the pictures carried by itinerant Indian story-tellers and preachers. Its purpose is entirely didactic and, while this could probably also be said of every *t'angka*, their message is hardly as direct or so basic as in the Wheel of Life. According to one early text, it was said to have been described by the Lord Buddha himself and it represents, in pictorial form, the fundamental principles of Tibetan Buddhism. In the centre are the three cardinal sins symbolized by the red cock (passion), the green snake (hatred) and the black pig (stupidity). Next, outside these and descending on the right from top to bottom, are victims of bad *karma* on the path to hell while, from the bottom upwards on the left, are beings destined for *Nirvana* as a result of good *karma*. Next, outwards, are the six spheres of existence; starting at the top in clockwise order are:- the realm of the gods, the realm of the rebel gods (and their war with the gods), the realm of the tantalized ghosts, the realm of the hot and cold hells, the realm of the animals and fishes, and the realm of the human beings. The rim of the wheel is made up of twelve segments representing the twelve *Nidanas*, which are the links in the chain of causation; these were assembled and rehearsed three times by the Lord Buddha during the night in which he achieved enlightenment and therefore represent the culmination of his search for truth. The animal clasping the wheel is sometimes regarded as symbolizing Impermanence and sometimes Mara (Death). The Wheel of Life can be used for instructing the illiterate and it may be for this reason that it is often found painted on the wall next to the main entrance door to a temple.

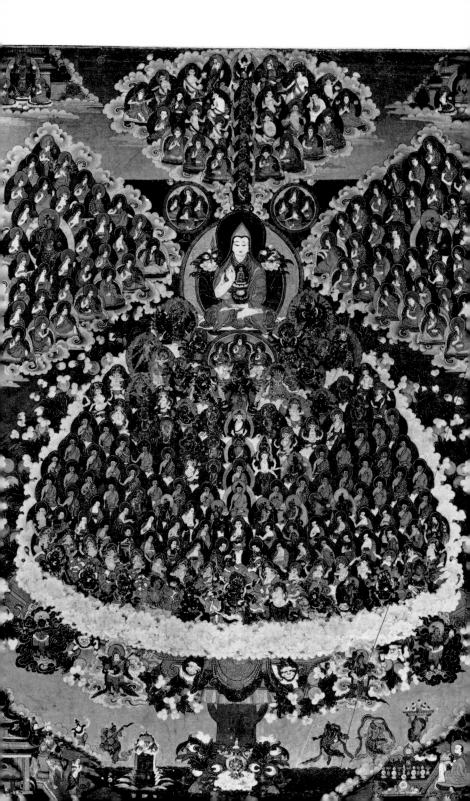

28 Assembly Tree of the Gods *(Ts'ogs-shing)*. *T'angka.*
Probably early 19th century. 154.4 cm. (61 in.), 81.8 cm.
(32¼ in.). I.M.229–1920

In the centre is the figure of Tsongkapa; he has a figure of
Shakyamuni in front of his chest, who in turn has figures of
Vajradhara (see pl. 1) and his *prajna* on his chest. To the left is
Maitreya, surrounded by scholars of the Gelukpa sect (see pl.
21), and on the right Manjushri also surrounded by scholars of
the Gelukpa sect. Above are figures of Indian teachers and
Manjushri, and below are deities belonging to the pantheon,
Buddhas, Bodhisattvas, female deities, Guardians of the Faith
(*Dharmapalas*), Gods of the Four Directions (*Lokapalas*), etc.
Below them the trunk of the tree emerges from the primeval
waters from which all life emerges and to which all will return.

In some cases the Assembly Tree has only the figure of the
Buddha Shakyamuni in the centre, or, more rarely, another
deity. The tree may contain many figures, such as this one, or
it may portray only a few of the more important ones. The
subject is a popular one in Tibetan painting and, like the
Wheel of Life shown in pl. 27, may be used as an aid to
religious instruction for the illiterate.

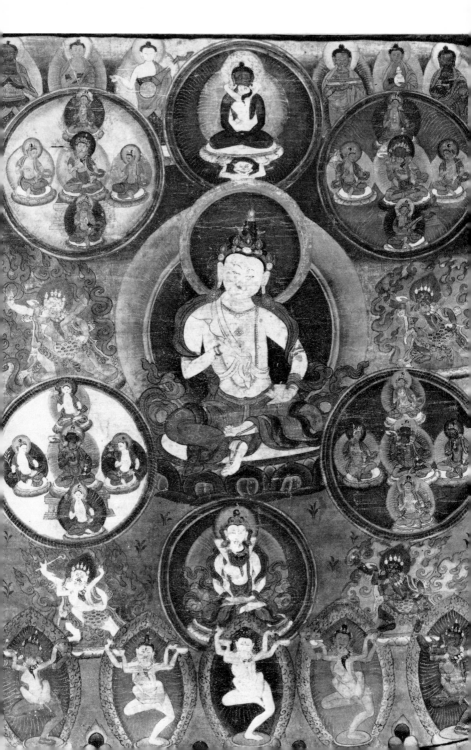

29 The Adi-Buddha Vajrasattva surrounded in *mandala* form by the peaceful deities mentioned in the *Ch'os-nyid Bar-do*. *T'angka*. Probably 18th century. 65 cm. (25½ in.), 46 cm. (18⅛ in.). 05319 I.S.

The *Ch'os-nyid Bar-do* is part of a text which describes the transitional states immediately after death; it is concerned with the third stage, that of 'Experiencing Reality'. This *t'angka* is intended to illustrate the advent of the peaceful deities which appear from the first to the seventh day of this stage (the five who appear on the seventh day have, however, been omitted). Arranged in groups within rainbows surrounding the central figure they form a *mandala* corresponding precisely with the text, which not only describes them but also their function in relation to the 'soul', who is in transition towards rebirth.

It is likely that this *t'angka* originally was one of a pair showing all the deities which appear during this stage.

The Buddhas of the six spheres of existence shown along the top of the *t'angka* can also be seen in the six segments of the Wheel of Life shown in pl. 27.

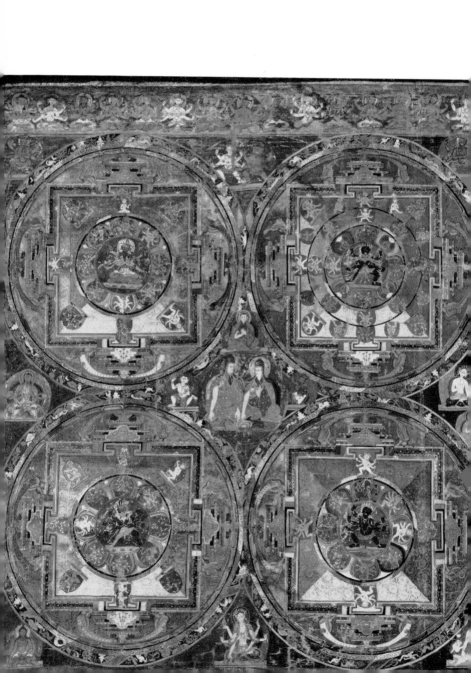

30 Four mandalas. *T'angka.* Probably about A.D. 1450. 73.7 cm. (29 in.), 67.2 cm. (26½ in.). I.S.167–1964

A painted *mandala* usually shows deities (or symbols, or both) systematically arranged round a central figure, the whole group being enclosed in the stylized plan of a rectangular building with a door in each wall which faces one of the four cardinal points of the compass; this is further enclosed in a series of circles often consisting of flames, thunderbolts, cemeteries, and lotus petals (but see below). The *mandala*, representing a main deity and his (or her) supporting deities, or retinue, is drawn strictly in accordance with a written description and is used mainly for meditation. By contemplating the *mandala* in the way in which he has been trained, and sometimes aided by further instructions given in the text which describes the *mandala*, the person meditating on it temporarily occupies the place of the central figure and thus acquires some of its attributes and powers. Painted *mandalas* are more often confined to single examples on each scroll painting, but several can be superimposed on top of each other or, as here, two or more can be painted side-by-side. Occasionally, as in the *t'angka* shown in pl. 29, the circular and architectural format may be eliminated and the figures, which would otherwise be placed round the central deity in circles, are arranged in another way.

This *t'angka* was probably painted at the Ngor monastery in Tibet soon after its foundation in A.D. 1429 by a Nepalese painter. The subjects of the *mandalas* have not been identified; the figure in the centre between the rims of the two lower *mandalas* is identified by an inscription as Ushnishavijaya.

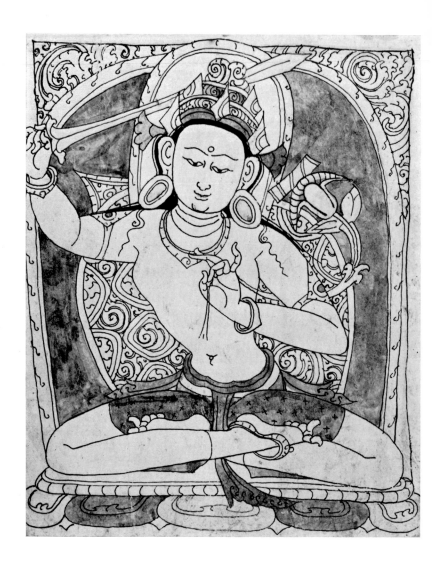

31 Manjushri. Drawing on paper in ink and thinly applied gouache. Probably 13th or 14th century. 10.3 cm. ($4\frac{1}{16}$ in.), 8.7 cm. ($3\frac{7}{16}$ in.). I.M. 121E–1910

This drawing, with several others, was found in the base of the Buddha figure shown in pl. 2. It is a fine example of an unusual technique and also of the expressive use of line which is characteristic of Tibetan painting such as that shown on the t'angkas in pls. 20 and 24. Since the drawings in this group, found in the image, are too large for manuscript illumination and were evidently not intended as t'angkas it is probable that they were supposed to represent the deities themselves in consort with the Buddha.

The style of drawing shows several Nepalese idioms, including the treatment of the crown, the foliage motifs at each of the top corners and the triangular element at the point where the halo joins the mandorla. This suggests the way in which Tibet and her neighbours probably exchanged their artistic styles and motifs along with much of their religious and material culture. Under these circumstances, the precise attribution of provenance is not only difficult but also, to a certain extent, irrelevant. It might possibly be equally correct to describe this drawing as Nepalese.

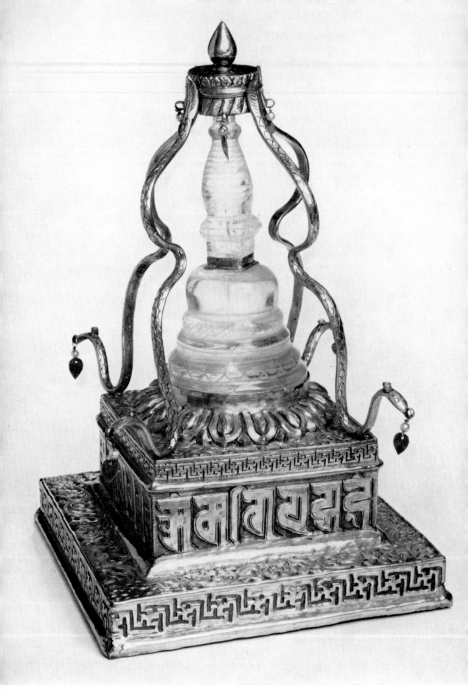

32 *Stupa* (relic mound). Rock crystal on a base of copper embossed and gilt; the *pipul* leaves hang from small pearls. Date uncertain. 24.1 cm. (9½ in.), 15.2 cm. (6 in.). I.M.29–1933

The fact that the crystal *stupa* bears a resemblance to the *stupa* at Kirtipur, Nepal, suggests that it may have been intended to represent it and thus may be of Nepalese origin. The workmanship of the metal parts does not strongly imply any particular source within the area of Tibetan Buddhism. It is conceivable that this is a composite piece, the crystal and the metal parts having been made in different places.

The architectural *stupa* as a burial mound probably has pre-Buddhist origins in India. Later it was used to house relics of the Buddha after his cremation and later still *stupas* were erected over places which had become sacred to his memory. In Tibet they may be used as reliquaries and to house images or sacred texts.

Miniature *stupas* such as this one, or cast in bronze or brass, represent the spiritual plane of the Three Supports (the three elements which comprise the quintessence of every being): the other two are the book (representing the verbal plane and, therefore, words, see pl. 34) and the image or painting (representing the physical plane).

The presence of all three supports, an image or painting, a book and a *stupa* is important for many kinds of ritual.

The *mantra* to Avalokiteshvara (see pl. 49) is embossed round the platform of the *stupa* in Lantsa letters; the other bands of decoration comprise the swastika motif symbolizing the endless movement of life.

The *mantra* representing the Three Supports is shown on the outside of the back cover of this booklet.

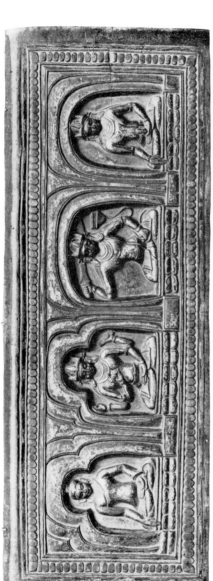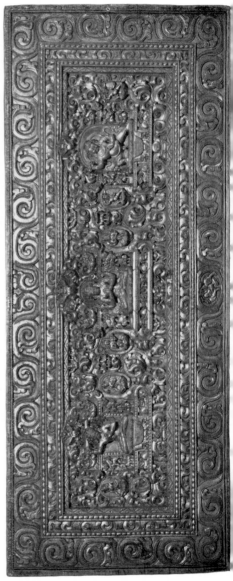

33a–b Two Book-covers. Wood carved and gilt and with traces of pigment. **33a** probably 14th or 15th century. 28.2 cm. (11 in.), 72.4 cm. (28½ in.). I.M.180–1913. **33b** 17th or 18th century. 27.5 cm. (10⅞ in.), 73.4 cm. (28⅞ in.). 540–1905

These covers are placed above the pages of the book, which are first wrapped in cloth; a corresponding piece of wood, either plain or less elaborately carved, is placed below the pages, which are unbound. The iconography of the images carved on the front cover is related to the text which forms the contents of the book.

These two examples illustrate the changes which took place in the style of decoration on book covers in the three or four hundred years which separate them. In the upper illustration (a), the style is simple and restrained and its relationship with Nepalese manuscript illumination is shown by the treatment of the crowns worn by the three figures on the right. The cover in the lower illustration (b) shows Tibetan decoration at its most developed and assured. Foreign elements have been completely absorbed and the handling of the scroll-work both along the borders and in the central panel, as well as the treatment of the point of the arches enclosing the figures so that they project into the border, show a masterly control of the medium.

Both of these covers were brought back from Tibet by members of the Younghusband expedition, which took place in 1904–05.

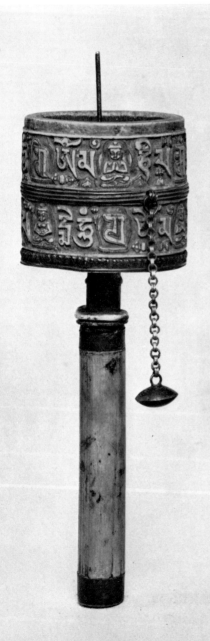

34 Prayer Wheel. Ivory, bone, and embossed and gilt silver. The metal mounts probably 18th or 19th century, the ivory drum perhaps of earlier date, possibly 15th or 16th century. L. 25.9 cm. (10¼ in.). I.M. 172–1910

In Tibet the word, either spoken or written, is considered as forming one of the Three Supports (see pl. 32) and is therefore sacred. Merely to read or write prayers or extracts from the scriptures (or to pay for them to be read or copied) are acts of spiritual advancement. Some liturgies involve the repetition of the same formula over and over again in order to achieve a desired end. By an extension of the same principle it is believed that spiritual benefit can accrue by rotating prayers written on rolls of paper. This may be by small prayer wheels, such as the one illustrated, turned by hand, or by others turned by hot air, wind or water. The roll of paper inside the prayer wheel shown in the illustration has the invocation to Avalokiteshvara *Om mani padme hum* printed on it many times (see pl. 49); the same formula is carved on the ivory drum both in Tibetan script and in Lantsa letters (see also pl. 49) interspersed with the Tibetan (three syllables in the top row and three in the bottom). Also spaced among the lettering are carved Buddha figures, bells, thunderbolts, lotuses and rocks.

It is almost certain that prayer wheels are a Tibetan invention. In this form they are not found outside areas which have received their Buddhism from Tibet.

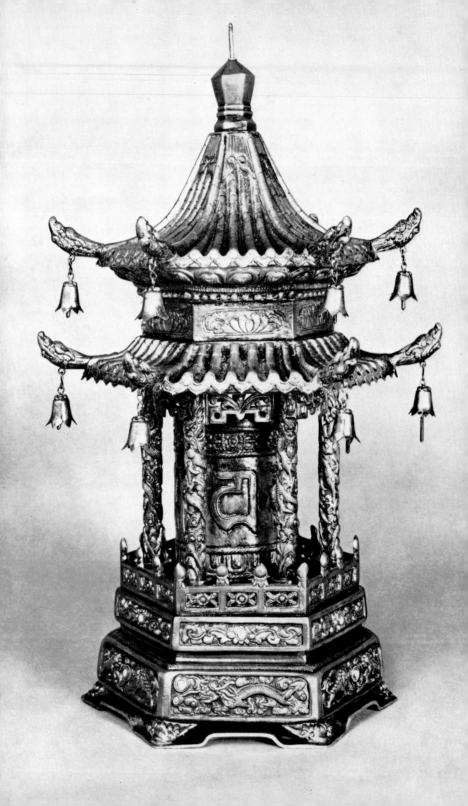

35 Table Prayer Wheel (one of a pair). Embossed and en-
graved copper, partly gilt and set with turquoises. Probably
18th or 19th century. H. 38.7 cm. (15¼ in.). I.M.119–1911

This belongs to the same group of prayer wheels mentioned in
the caption to pl. 34, and involves exactly the same principles.
The roll of paper on which the prayers are written is contained
in the central drum, which is turned by means of the spindle
which forms the finial to the roof. The similarity between the
design of this prayer wheel and some forms of Chinese
architecture, such as pagodas, is most striking. Its elaborate
treatment contrasts with simpler types, more Tibetan in style,
which are in the form of either cylinders similar to those of
hand prayer wheels or cylinders with a cone-shaped top. The
one shown in the plate opposite was probably made in China
and may have formed part of a gift from an emperor, or other
important person, to a Tibetan Lama in acknowledgment of his
influence or learning. It is a reminder of the close relationship
which existed between the religion of Tibet and the Mongols
during the Yüan period in China, and again under the Manchus
during the Ch'ing dynasty, when Tibetan religion was
encouraged at such famous centres as the Potala at Jehol
(Ch'eng-te) and, above all, at the Yung-ho-kung temple in
Peking, where not only Tibetans worshipped, but also Chinese
converts, Mongols, Kalmucks, Tanguts and Nepalese.

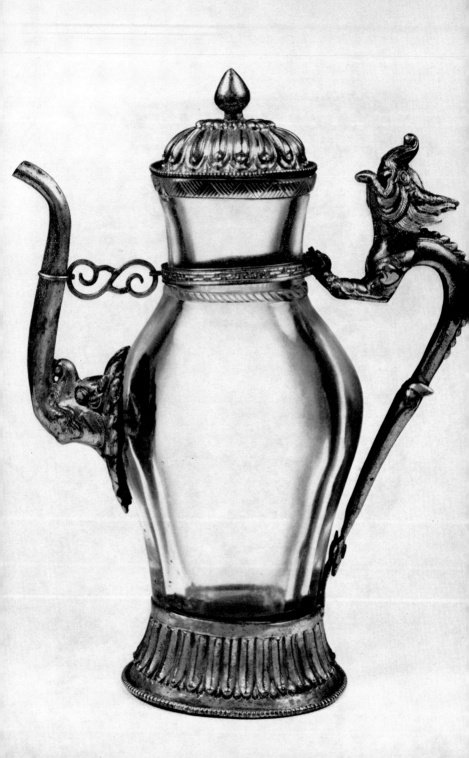

36 Libation Jug. Rock crystal with mounts of gilt copper. Possibly 17th or 18th century. H.14 cm. (5½ in.). I.M.379–1914

The skill in working rock crystal, and the exquisite craftsmanship of the mounts, has created, in this jug, an object which brings to mind the work of Benvenuto Cellini. Its small size and the delicate treatment of the ornamental detail place it almost in the category of jewellery. The finial of the lid is in the form of a closed lotus bud (sometimes seen above the *ushnisha* of Buddha figures, see pls. 2, 19 and 20), while the rest of the lid is decorated with open lotus petals (also similar to the lotus thrones of images such as those shown in pls. 7, 15 and 17). The handle and the spout are in the form of *makaras*, which are Indian mythological animals belonging to the reptile family. The base repeats, but with different treatment, the lotus petal motif of the lid.

This jug was probably part of a four-piece set (*gser-skyems*) used for ritual purposes. Its form is related to other similar examples which are usually silver and which have Chinese symbols, such as bats and cranes, forming part of the decoration and which are also for religious use. These may be of Chinese workmanship but originally each (Tibetan and Chinese) probably owes its shape to that of Persian ewers.

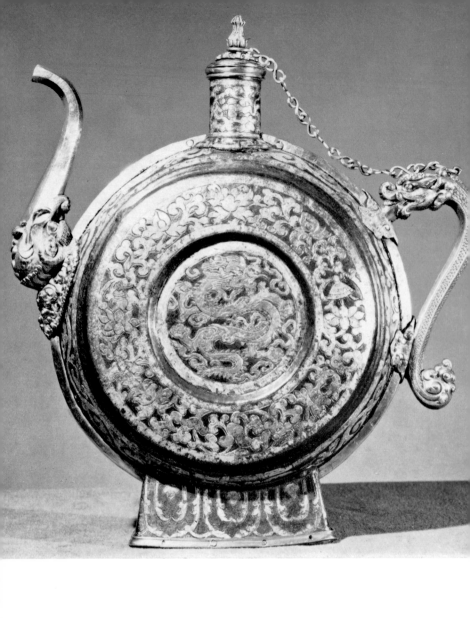

37 Beer Jug. The body of iron with the pattern of damascened gold, the spout, handle and lid mounts of gilt copper. 18th or 19th century. 41.9 cm. (16⅞ in.), 38.1 cm. (15 in.). I.M.22–1928

The dragon motif in the centre (see pl. 42) and floral decoration enclosing the Eight Auspicious Emblems (see also pl. 42) are evidently Chinese in stylistic treatment. The animal heads on the spout and handle, which are also found on Tibetan tea-pots, are those of the Indian mythical monster, *makara* (see pl. 36). This is one of several types of Tibetan jug for containing beer. It was probably made for domestic use and is related in design and technique to vessels which are similar but have no spout or handle. Both types are almost certainly from Eastern Tibet.

Beer is used as an offering during rituals connected with the worship of several deities. Sometimes it represents blood, possibly as a substitute for the real thing in ceremonies having a pre-Buddhist origin. Visitors to chapels dedicated to Padmasam-bhava are sometimes offered beer instead of water (see pl. 40).

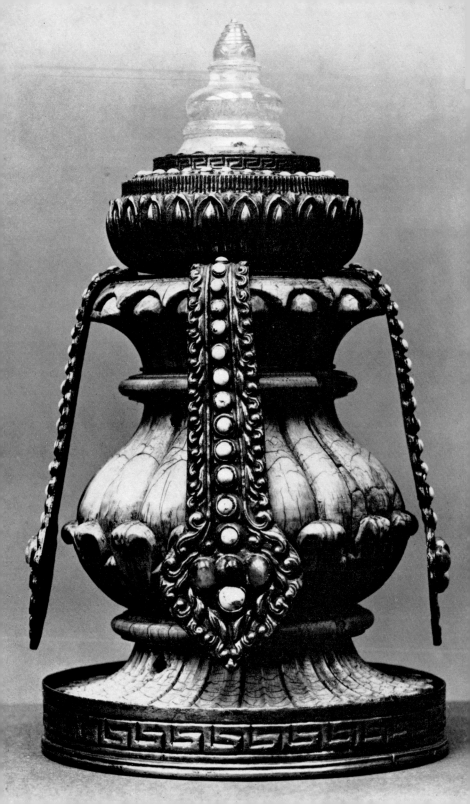

38 *Amrita* Vase. Silver gilt set with semi-precious stones, and ivory with the top in the form of a crystal *stupa* (see pl. 32). The ivory body is probably Indian (Mughal), 17th century, the rest possibly late 18th or early 19th century. H.19 cm. ($7\frac{1}{2}$ in.), Diam 10.8 cm. ($4\frac{1}{4}$ in.). I.M.95–1911

The use of an object from an entirely foreign (Muslim) culture is evidence of the wide-ranging activities of the Tibetan trader, and the catholicity of his taste.

The word *Amrita* is etymologically related to the word ambrosia and has roughly the same meaning. In the story from the Indian epic in which the demons and gods churned the milky ocean for a thousand years, the physician of the gods, Ghanvantari, appeared carrying the moon in the form of a bowl which contained *Amrita*, the elixir of immortal life. The idea of *Amrita* conferring immortality entered Buddhism together with a great deal of other Indian mythology. Originally it was equated with *Nirvana* but later, possibly with the development of Tantrism, it took its place with other techniques by which mortals could achieve escape from rebirth, or acquire longevity. Not surprisingly, this vase is the symbol held by Amitayus (the Buddha of eternal life) and consecrated liquid intended to represent *Amrita* may be used in rituals performed as part of the cult of Amitayus.

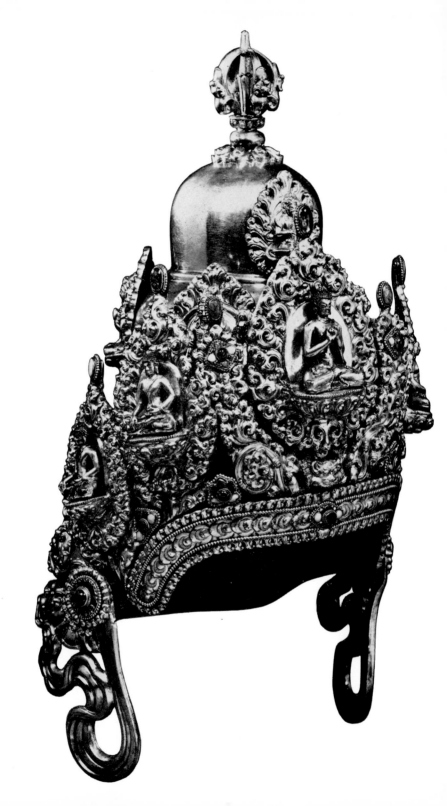

39 Helmet. Embossed and gilt copper, set with semi-precious stones. Probably 18th century. 76.2 cm. (30 in.), 24.1 cm. (9½ in.). I.S.5–1946

Helmets of this type are worn by certain categories of Buddhist teachers (*acharyas*) who might be equated with professors or, here perhaps more precisely, teachers of the *Vajrayana* texts of Buddhism. This headdress incorporates the five-leaf crown of the Bodhisattva, each leaf decorated with a Buddha representing one of the five Buddha families. The upper part is in the form of a sacred relic-mound (*stupa*) surmounted by half of a thunderbolt (*vajra*) symbol.

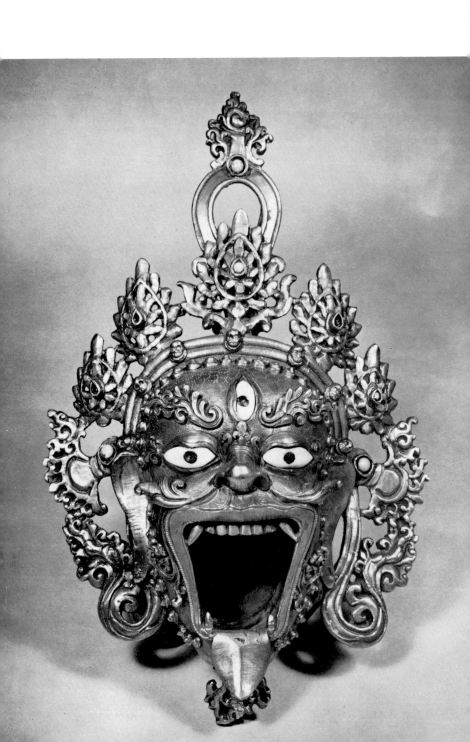

40 Holy Water Vessel. Cast brass engraved and inlaid with turquoise, ivory and black stone. Probably 18th century. L. 30.5 cm. (12 in.), W. 19.7 cm. (7¾ in.). I.M.162–1910

In the illustration this vessel is shown standing up so that it can be more easily seen; normally, however, it should lie back on three feet (sometimes in the form of skulls) so that the mouth points upwards. The face has the fierce expression of a 'defender of the faith' (see pl. 15).

In Indian mythology, from which Buddhism sprang, water has a fundamental place with associations going back to the most ancient times. Before creation began, it was believed that only water and darkness existed. So closely is water regarded in its association with deities that it has become one of the vehicles by which the gods can manifest themselves. Even today a jar of water is an acceptable substitute for an image in the daily ritual of simple folk. In Tibet a pond or lake in which water-deities are living can form the object of the pious act of circumambulation. In Tibetan religious ritual water plays an important part in many ceremonies, such as the seven small bowls of water which may be made as offerings to almost any divinity and the holy water which the candidate drinks as part of his consecration ceremony. Visitors to Tibetan chapels who make an offering, or present a scarf, are often given water in their cupped hands to drink and rub on their forehead.

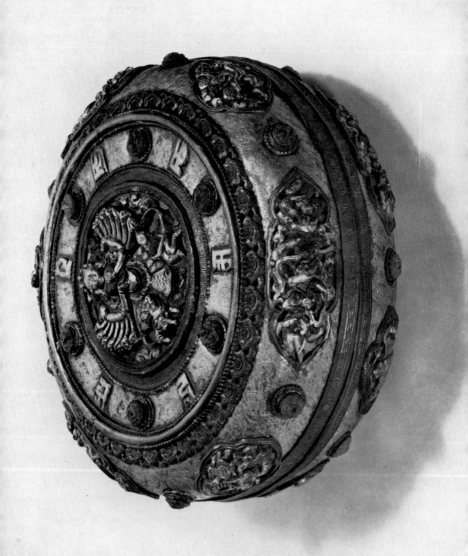

41 **Bowl and Cover.** Embossed copper set with semi-precious stones. 18th or 19th century. Diam. 22.2 cm. (8¾ in.), Depth 9.5 cm. (3¾ in.). I.M.96–1911

The *mantra* to Avalokiteshvara (see pl. 49) is inscribed round the lid in raised Lantsa letters.

The mixture of decorative motifs and techniques used on this bowl and cover illustrate the difficulty which arises, in some cases, of deciding in which area an item of apparently Tibetan art might have been made. The engraved and gilt decoration and the key-pattern suggest Chinese metalwork while the treatment of the figure in the centre of the cover and the carved stones similar to carnelian are characteristic of some Nepalese workmanship. But wherever this bowl and cover were made it was in an area unequivocally owing attachment to Tibetan Buddhism, and by a craftsman who naturally made use of foreign decorative elements in his work. This ambiguity of provenance is not uncommon with objects of 'Tibetan' art. At all periods Tibet seems to have welcomed artists and craftsmen from the countries by which she is surrounded; at the same time her own were indefatigable travellers. In these cases it is only possible to interpret the word 'Tibetan' in its broadest sense as indicating a highly eclectic style shared by several countries which have, in part at least, adopted the material means of expression of Tibetan religious culture.

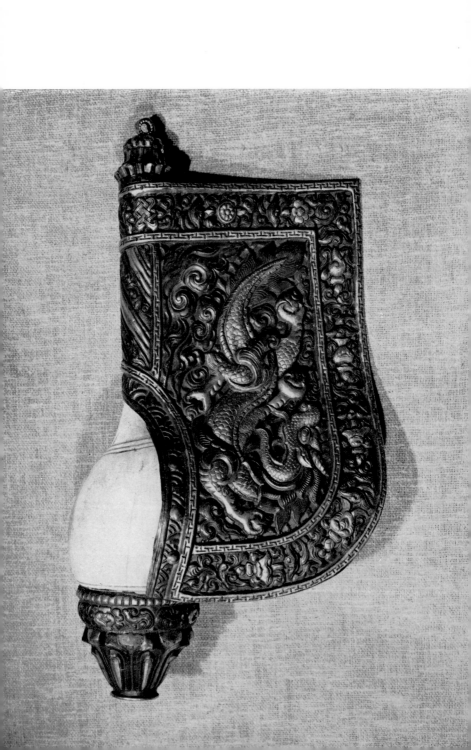

42 Conch Shell Trumpet. Natural conch shell mounted with embossed and gilt copper. Probably 19th century. L. 45.1 cm. (17¾ in.), W. 25.4 cm. (10 in.). I.M.154–1927

The dragon, which is the usual form of decoration on the metal apron of the conch shell trumpet, evidently owes much to the similar treatment of the same subject in Chinese art, although here it has also become related to the *nagas* (snakes) and *makaras* of Indian art. Included in the border decoration are the Eight Auspicious Emblems (umbrella, pair of fishes, conch shell, lotus flower, wheel, banner of victory, vase and endless knot), which are probably the most common decorative motifs in both religious and secular Tibetan art.

These trumpets are usually blown in monasteries to summon the monks to attend religious services. Their use is almost certainly another importation from India, where conches are blown in Hindu ritual to draw attention to an image that it is about to be worshipped.

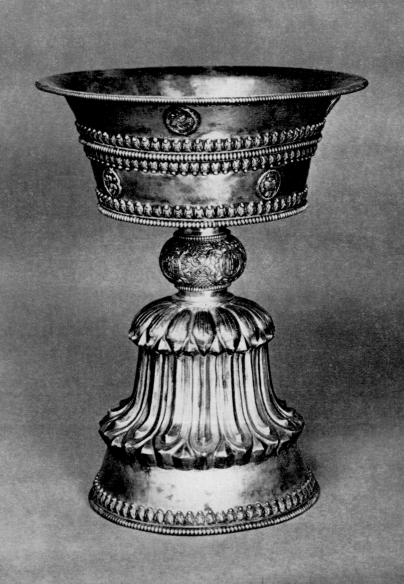

43 Butter Lamp. Silver embossed and engraved. 18th or 19th century. H. 22.8 cm. (9 in.), Diam. 19.4 cm. (7⅝ in.). I.M.527–1905

Probably nowhere else is the skill of the Tibetan silversmith more apparent than in the making of butter lamps. Usually following a similar pattern, they have a wide bowl for holding the butter and a small twist of cotton for the wick; this is supported on a bulbous stem resting on an inverted lotus flower. They seem to be a favourite gift for offering to a monk or a monastery; some lamps carry inscriptions recording not only such a donation but also details such as the weight of the silver employed. In wealthy institutions butter lamps may also be made of gold.

No altar is complete without at least one butter lamp, preferably kept burning all the time. In photographs of altars taken by travellers to areas where Tibetan Buddhism is practised there are usually several, while, for special occasions, in large monasteries there may be a hundred or more.

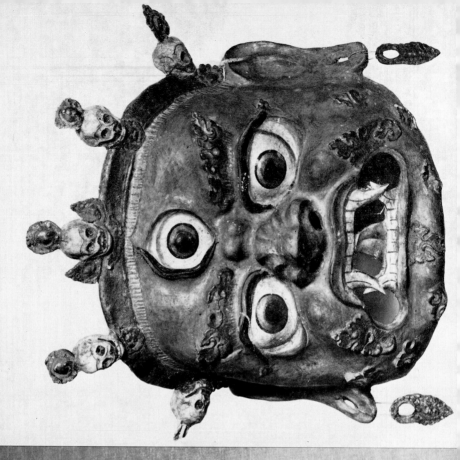
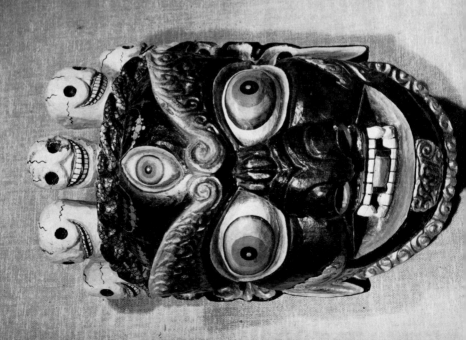

44a–b Two Dance Masks. 44a (left), wood, carved and painted and partly gilt, perhaps from Sikkim. 18th or 19th century. 50.8 cm. (20 in.), 34.3 cm. (13½ in.). I.M.66–1938. **44b** (right), papier-mâché; probably from central Tibet. 18th or 19th century. 44 cm. (17¼ in.), 39 cm. (15¼ in.). I.M.93–1937

Dances in which masks similar to these are worn form part of the observances of some religious rites in Tibet and can be compared with Christian mystery plays. They are performed by all sects (including Bon-po) and often take place outside monasteries, usually towards the end of the year. Their theme is frequently an allegory of the struggle between good and evil, particularly as it is expressed by the conflict between Buddhism and its enemies during the early period of Tibetan history. The dances are accompanied by music provided by trumpets, drums and a double-reed instrument similar to an oboe, which reflects the mood of the dance-drama as the story unfolds.

The characters represented by the masks illustrated probably belonged to the group of minor defenders of the faith whose fierce expression is intended to frighten away the enemies of Buddhism (see pls. 15 and 40).

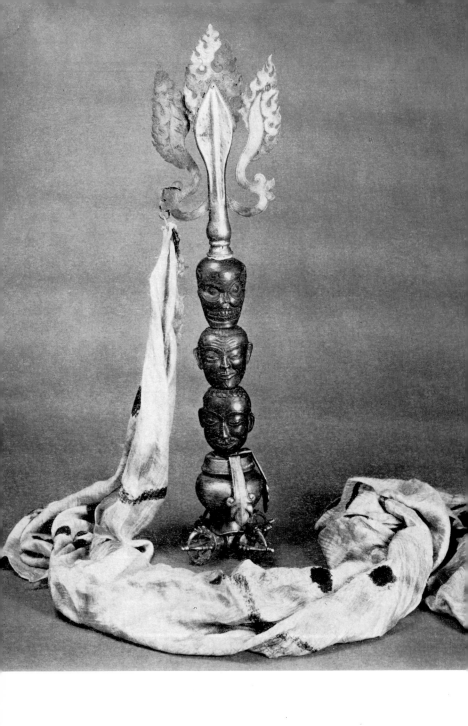

45 Head of a Staff. Copper (formerly painted) and gilt, with two silk streamers. Possibly 17th or 18th century. L. 57.5 cm. (22⅝ in.). I.M.80, 80A & 80B–1935

This staff-head is identical with that which is sometimes held by Padmasambhava (see pl. 26) and it may have come from a large image of him. Each part of the staff has its symbolic meaning; the three prongs represent the three Buddhist realms of existence and the flames which surround them are the divine wisdom which consumes ignorance; the skull and two heads represent the divine bodies of universal essence; the vase contains the nectar of life (*Amrita*, see pl. 38); the four points of the double-thunderbolt (*vishvavajra*) represent peace, the dual aspect of existence, the power of initiation (into tantric rites), and fearfulness (of the results of sin); the streamers symbolize the banner of victory (over ignorance).

This is an excellent example of the capacity of Tibetan Buddhism for endowing everything with a religious symbolism, which is similar to that of Christian medieval Europe.

The silk for the streamers was made in India and is decorated with an Indian tie-and-dye (*bandhana*) pattern.

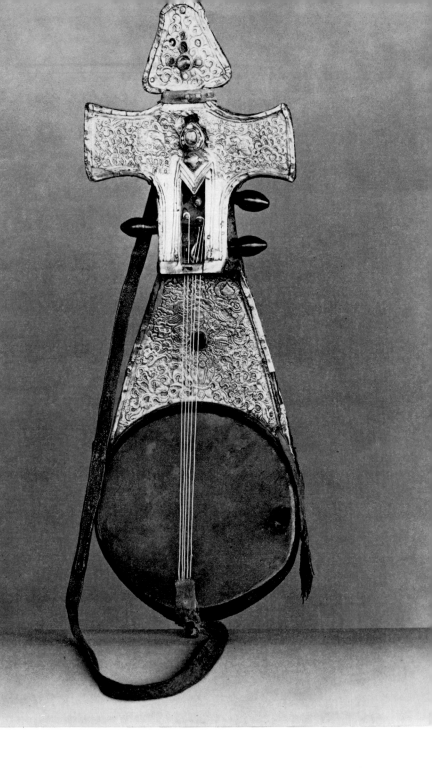

46 Musical Instrument. Wood overlaid with embossed silver and set with semi-precious stones; the sound-box is covered with skin and the four strings are of twisted brass wire. Date uncertain. 76.2 cm. (30 in.), W. (greatest) 26.7cm. ($10\frac{1}{2}$ in.). I.M.3–1938

Tibetan musical instruments fall roughly into three categories: wind instruments in which the sound is produced either from a metal cup-shaped mouthpiece (as for example in the long, ceremonial trumpets) or from a double-reed instrument similar to an oboe except that the reeds are held in the mouth instead of between the lips; secondly, there are several types of drum, such as the large, double-sided type which is struck with a curved stick; lastly, there are stringed instruments, of which one with a waisted sound-box (similar to the Indian *Rebab*) and having a curved neck ending in a horse's head seems to be the most common. The one in the illustration appears to be related to the Chinese *Yüeh-ch'in*. The method of attaching the strings to the sound-box by means of a piece of leather seems to be conducive neither to the transmission of the vibrations to the sound-box nor to keeping the strings in tune.

Music has both a lay and a religious function in Tibet but the instruments and the nature of each function are strictly separate. It accompanies folk songs, religious rituals and the dance dramas based on religious themes (for two of the masks worn at these dramas see pl. 44). In religious music a form of notation has been evolved which relates the music with the words which it accompanies as well as giving the performer an indication of how it is to be played.

The instrument illustrated here is not unlike that held by the figure of Dhritarashtra shown in pl. 9.

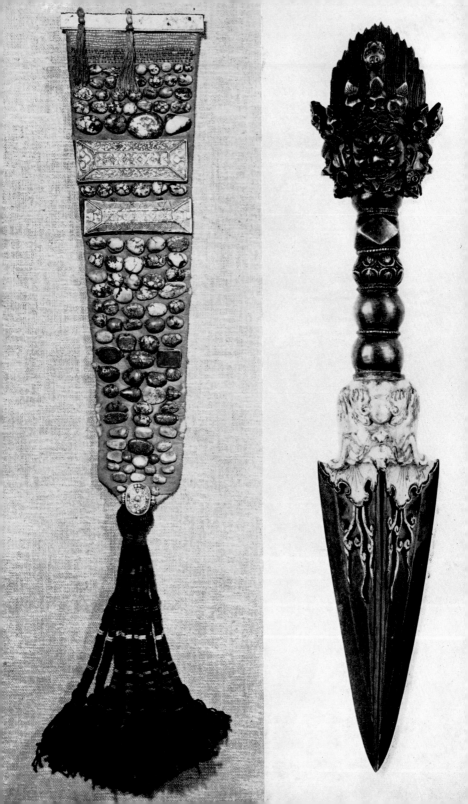

47a Part of a Headdress. Wool fabric decorated with embossed silver ornaments, unworked pieces of turquoise, and semi-precious stones. It is impossible to assign a date to this object with any certainty, but it is unlikely to be earlier than the late 18th century. L. 96.5 cm. (38 in.), W. (greatest) 12.7 cm (5. in.). I.S.7–1954

Although Tibetan art is capable of the most subtle sophistication, it seldom completely loses its connection with the folk art of the semi-nomadic groups belonging to its northern regions. This is well illustrated by the combined use of silverwork and natural stones with coarsely woven wool to make the part of a headdress shown opposite. It was attached in the centre at the back of the wearer and hung down so that the end was about at the level of the waist.

47b Exorcising Dagger (*P'ur-pa*). Bronze, engraved and gilt. Probably 18th century. L. 38 cm. (15 in.). I.M.72–1929

The Tibetan name means 'peg' or 'nail' rather than the dagger as a weapon. It is used in rituals performed in order to defeat the unwelcome attention of evil spirits. In Tibet, where almost nothing happens as a result of natural causes or by accident, the malevolent forces which bring about illness, minor mishaps or disasters have either to be propitiated before they can begin their work or, if they have already made their presence felt, driven away. The *p'ur-pa* is endowed with the magic power to hold down evil spirits so that they may more easily be made the subject of the ceremonies by which they are expelled.

The top of the dagger is usually in the three- or four-headed form of the horse-headed (more precisely, horse-necked) deity Hayagriva. This is one of the many gods taken over, either directly or indirectly, from Hinduism. He is mentioned in the *Puranas* as being a demon to defeat whom Vishnu had to take on the form of a horse-headed man. He clearly originated in the primitive animism not only of India but also of Central Asia.

The handle of the *p'ur-pa* is often in the form of a stylized thunderbolt (*vajra*), while the triangular blade is held in the jaws of a *makara*, which is a mythical monster well known in Indian legend.

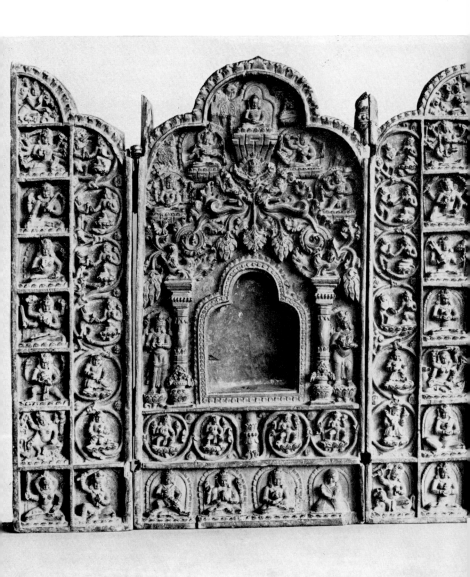

48 Portable Shrine. Carved wood formerly painted. 15th or 16th century. 42.6 cm. (16¾ in.), 43 cm. (16⅞ in.). I.M.1–1938

The two Bodhisattvas standing outside the columns on each side of the niche suggest that the shrine may originally have contained a figure (probably bronze) of the Buddha Shakyamuni but this is by no means certain. Amitabha appears at the top, and other figures include several forms of Manjushri, Shadakshari, Vajrapani and *Dharmapalas* and, at the bottom right of the central panel, a monk, who was possibly the spiritual preceptor of the donor of the shrine. At the top left are seal impressions on red wax, probably denoting the monastery to which it belonged.

Two distinct styles are represented in the design of this shrine. The curving tendrils enclosing figures belong to western Tibet. This motif may have come to this area from the late Hellenistic art of ancient Rome by way of the art of Gandhara (see pl. 26). The treatment of the columns and arch over the image-niche, and the figures enclosed in rectangles at the edge of each wing are very similar to Nepalese painting of this period.

The form of this shrine, with two doors opening to form a triptych, is similar to Central Asian examples of an earlier date. These, in turn, are probably based on European Christian portable shrines, made in the same shape of ivory and metal, during the late Byzantine period. It is possible that these were carried from the eastern Mediterranean to Central Asia by Christian missionaries or travellers.

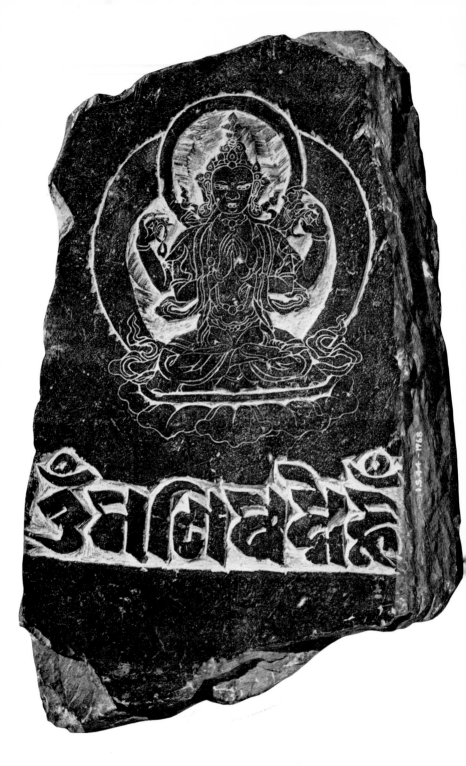

49 Shadakshari (Avalokiteshvara). Incised stone. Date uncertain. L. (greatest) 34.3 cm. (13½ in.), W. (greatest) 20.2 cm. (8¾ in.) I.S.44–1968

Below the figure of the deity is incised the six-syllable invocation (*mantra*) to Avalokiteshvara *Om mani padme hum* in Lantsa script. Although not all stones decorated in this way have this *mantra* on them or, even, necessarily show figures of Avalokiteshvara, the second two syllables have given their name to this group of religious objects, which are known as Mani-stones. Belief that the repetition of sacred verbal formulas can have a positive beneficial effect for the speaker probably has pre-Buddhist origins in India and similar parallels can be found in many primitive societies. The *Om mani padme hum* formula, the use of which is now almost entirely confined to those whose faith is Tibetan Buddhism, originated in Indian Buddhist texts possibly belonging to the period between the first and the fifth century A.D. While there has been much learned speculation as to the precise meaning of this formula, no universally accepted explanation has been given. The *mantra* is often written, as here, in Lantsa script, but it can also be found on Mani-stones (and elsewhere) in Tibetan script (see pl. 34). Lantsa is a script originating in Nepal; it is a decorated form of the Devanagari script used in North India, Tibet and Nepal mainly for invocations (as here; see also pls. 32, 34, and 41), for the title pages of sacred texts and for texts themselves. Shadakshari is the form of Avalokiteshvara, of whom the Dalai Lama is an incarnation. Shadakshari-Lokeshvara is said to live in a paradise called Potolaka (Potala) which is symbolized by the Dalai Lama's residence in Lhasa having the same name. It is probably for this reason that images of this figure (both bronzes and in painting) are some of the most popular in Tibet.

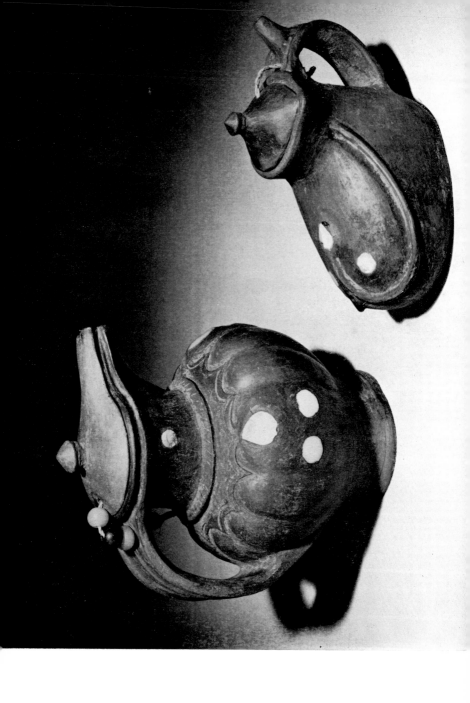

50 Jug and Drinking Vessel. Dark brown unglazed earthenware inset with pieces of porcelain (the lid of the jug is attached to the body by a piece of string threaded with dark- and light-green beads). E. Tibet; 19th century. Jug H. 15 cm. (5½in.); Drinking vessel H. 9.5 cm. (3¾ in.). I.M.35 & 38–1910

In a country where a large proportion of the population is nomadic or semi-nomadic it is not surprising that domestic eating and drinking utensils are often made of wood and metal rather than earthenware. In more settled communities the use of pottery vessels is a more practical and less uneconomical possibility.

Although pots are thrown on a wheel in eastern and southern Tibet, in other parts of the country they are more often built up or modelled in the moist clay. These are then fired in a simple kiln made of turf and stones. Exceptionally pots are glazed in another firing but as a rule they are left unglazed. Decoration may be added, as here, by insetting pieces of porcelain, perhaps fragments from imported Chinese tea-bowls which have become broken; modelled relief patterns or designs made by the impression of moulds are also used. The shoe-shaped vessel on the right in the illustration is similar in form to that of Tibetan chamber pots. It was, however, probably used for *chang* (Tibetan beer). The short spout extending from the handle is joined to the body so that the liquid may be sucked out.

Index

The *mantra* OM AH HUM, written vertically in Tibetan script from top to bottom, is shown on the back cover. It represents the Three Supports (see pl. 32). It is often found on the back of images either painted or, in the case of bronzes, engraved. Sometimes each syllable is placed behind the appropriate area of the body, i.e. brain, throat and heart.